If on a Winter's Night ... Roni Horn ...

If on a Winter's Night ...

Roni Horn …

URS STAHEL (ED./HG.)

FOTOMUSEUM WINTERTHUR STEIDL

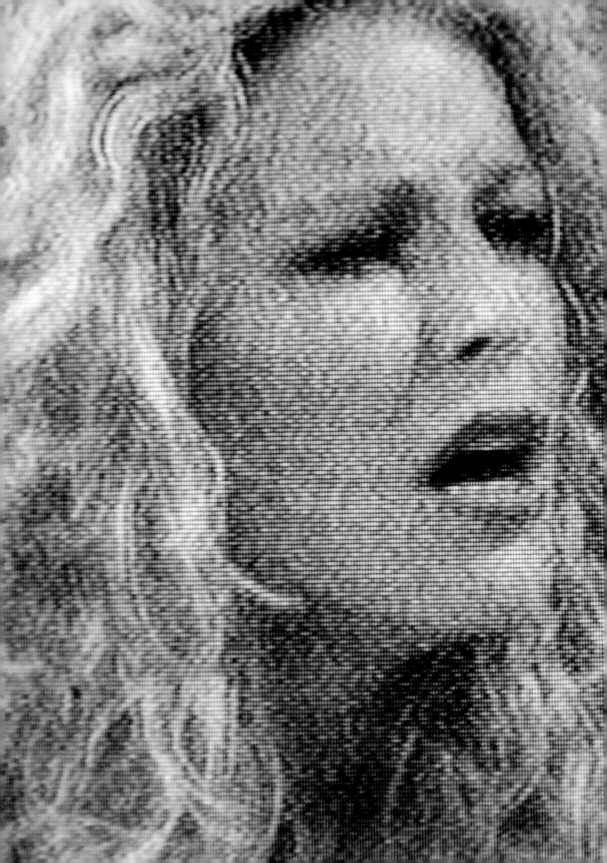

If on a Winter's Night

· Some women—shadows, ghosts, and girls (seen through peepholes) in a locker room · A gloss of water—telling of the *Water* in me (and you) · A selection, that is—*Some* (not all) of the water in the River *Thames* · A girl—almost *You*, almost *Me*, almost Bette Davis, (some even think Marlon Brando) · Hildur from Lübeck (where the best chocolate-covered marzipan comes from) · Geysirs or chandeliers (depending on the point of view)—are brought together—but not before

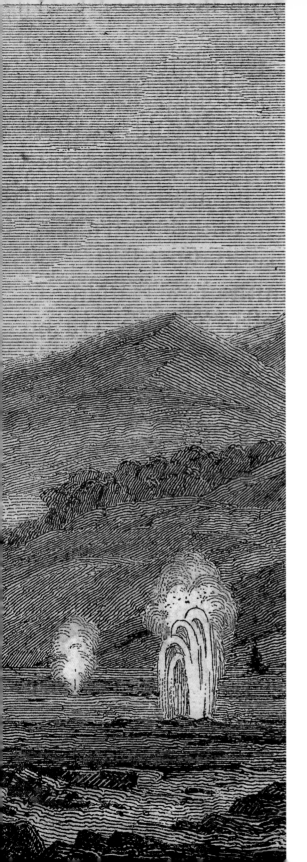

A Traveler to Iceland

· Discovers *Circles* in the *Arctic*—as well as the arctic along the Circle and while there · Watches Cassie Lane from *Guiding Light* help a rival deliver her baby behind a sofa and · Goes to Hildur's lighthouse at the northernmost point of Iceland (from which the Arctic Circle is visible) and then · Sends in a *Clowd*—sometimes *Blue*, sometimes *Gray* and a *Cloun*—sometimes *Blue*, sometimes gay and · Returns to the island and there · Enters a *White Labyrinth* yet to be discovered and if not, invented.

To enter Roni Horn's realm requires courage. Actually requires courage. But you only become aware of this after the fact, when it's already too late. Attracted by the bright white or the stringency of the installation, seduced by the many faces and pairs of eyes, fascinated by the labyrinthine and yet clear rooms, you enter her realm somewhat unsuspectingly. And then the lock clicks behind you, almost silently, and you are standing all alone in front of a work that upon closer inspection suddenly seems rather dry and reserved, seemingly repetitive. As seductive and attractive it seemed from afar—now it remains silent, mute even, and looks questioningly at the viewer: «And now? Where do we go from here?»

In many of the works that Roni Horn has created using photography— besides her work in drawing and sculpture and the power of her language— the viewer is standing in the center of a room, surrounded by a work building up along the walls, conceptually developing. The spatial center corresponds to a cognitive prerogative. The viewers are the center of the work, or rather the center of working, of executing the work. The work itself is an offer; it is an incision to look through, a corner to lean around, a line of faces with whom you can enter into an intellectual contact. The viewers have to break the silence and get this silent child to talk. Their searching, investigating, their going back-and-forth, their murmuring sentences set Roni Horn's work in motion, they make it flow, they discover something essential in the dialogue with the work.

And hence Elisabeth Lebovici continues the «title arrested in flight,» *Cabinet of*; she thinks about the bright white and the makeup of the clown, about emptiness and the becoming an image, about cosmogony and cosmetics in this work. bell hooks leads us to abysses of water, to its darkness and its unfathomable depths. Looking at *Another Water*, she wonders whether the yearning for water reveals a desire for unity with the elements. *This is Me,*

This is You consists of 48 pairs of images showing Georgia Loy, Roni Horn's niece, in all kinds of moods. The two images of a pair, however, can never be seen at once. Thus, Thierry de Duve runs from one room to the other and back again to detect minimal changes and explores the complex triangular relationship between Georgia Loy, Roni Horn, and himself. The author of this preface goes on a journey to the northernmost point of Iceland in *Pi* and experiences in the numerous circular movements of the work, how life on the Arctic Circle, in this precarious area, is possible thanks to an identity that seeks accord with nature and lives in harmony with necessity. In *Clowd and Cloun (Blue)*, Paulo Herkenhoff experiences the figure of the clown becoming unclear, diaphanous, yet never incorporeal, and the fleeting physicality of the cloud condensing into a compact mass. Following this chiasm, he goes on a quest for the «elusive treasures» in Roni Horn's work. The linguistic character and the precise, yet labyrinthine structure of *Her, Her, Her, and Her* prompt Barbara Kruger to write a poem in prose about this maze of locker rooms, about the coldness of geometry and of tiles, the borders between public and private, and the seduction into the realm of bodies.

These perceptions, these voices begin a dialogue with a work that seems eloquent because of its sequential polyphony, but which breaks many evolving narratives right at the beginning. The flow of its visual language impels the viewer to think, to circle around something that ultimately defies language and precise definition ... around central aspects of existence: place, time, and identity. The identity of the viewer, even. This is the point where the viewer grows afraid.

URS STAHEL

Das Reich von Roni Horn zu betreten verlangt Mut. Verlangt eigentlich Mut. Doch das merkt man erst im Nachhinein, wenn es zu spät ist. Angezogen vom hellen Weiß oder von der Klarheit der Anordnung, verführt durch viele Gesichter und Augenpaare, fasziniert von labyrinthischen und doch klaren Räumen, betritt man ihr Reich ein wenig ahnungslos. Und dann schnappt gleichsam das Schloss hinter einem zu, fein nur, und man steht alleine einem Werk gegenüber, das bei näherem Hinsehen sich plötzlich eher trocken, spröde gibt, versehen mit dem Anschein von Repetitivität. So verführerisch und anziehend es von weitem wirkte – jetzt schweigt es plötzlich, ist stumm, schaut den Betrachter fragend an: «Und nun? Wie weiter?»

In vielen Arbeiten, die Roni Horn mit dem Mittel der Fotografie ausführt – neben ihren skulpturalen und zeichnerischen Arbeiten und ihrer Kraft in der Sprache –, stehen die Betrachter in der Mitte eines Raumes, umgeben von einem Werk, das sich den Wänden entlang aufbaut, sich konzeptionell entwickelt. Dieser örtlichen Mitte entspricht auch die Erschließungsmacht: Die Betrachter sind die Mitte, genauer: das Zentrum des Aneignens, Erarbeitens, Vollziehens des Werkes. Das Werk selbst ist ein Angebot, ist ein Schnitt, durch den man schauen kann, eine Ecke, um die man sich beugen kann, eine Linie von Gesichtern, mit denen in gedanklichen Kontakt zu treten ist. An den Betrachtern ist es, das Schweigen zu brechen, das stumme Kind zum Reden zu bringen. Ihr Suchen, ihr Erforschen, ihr Vor- und Zurückschreiten, ihre murmelnden Sätze setzen die Werke von Roni Horn in Bewegung, bringen sie zum Laufen, zum Fließen, stoßen im Dialog mit dem Werk zu Essentiellem vor.

So führt Elisabeth Lebovici den «im vollen Flug angehaltenen Titel» des Werkes *Cabinet of* weiter, denkt über das helle Weiß und die Schminke des Clowns, über Leere und Bildwerdung, über Kosmogenie und Kosmetik in diesem Werk nach. bell hooks führt uns an die Abgründe des Wassers, zu

seiner Dunkelheit und Unergründlichkeit hin. Und sie fragt sich am Werk *Another Water*, ob dem Drängen zum Wasser eine Sehnsucht nach Vereinigung mit den Elementen zu Grund liege. Das Werk *This is Me, This is You* besteht aus 48 Bildpaaren, die die Nichte von Roni Horn, Georgia Loy, in den vielfältigsten Gemütszuständen zeigen. Die zwei Bilder eines Paares sind jedoch nie gleichzeitig zu sehen. So eilt Thierry de Duve von einem Raum zum anderen und wieder zurück, erspürt die minimalen Verschiebungen und erforscht das komplexe Dreiecksverhältnis zwischen Georgia Loy, Roni Horn und sich selbst als Betrachter. Der Autor dieses Vorwortes begibt sich in *Pi* auf eine Reise an den nördlichsten Punkt auf Island und erfährt in den vielen Kreisbewegungen des Werkes, wie Leben am Polarkreis, in dieser prekären Gegend möglich ist, dank einer Identität, die den Einklang mit der Natur sucht und in Eintracht mit der Notwendigkeit lebt. Paulo Herkenhoff erlebt in *Clowd and Cloun (Blue)*, wie die Figur des Clowns zu etwas Undeutlichem, Durchscheinendem, aber nie Körperlosem wird, und wie die flüchtige Stofflichkeit der Wolke zu einer kompakten Masse gerinnt. An diesem Chiasmus entwickelt er seine Suche nach den «unerfassbaren Schätzen», dem Verflüssigen im Werk von Roni Horn. Barbara Kruger schliesslich wird durch die Sprachlichkeit und die genaue und doch labyrinthische Struktur in *Her, Her, Her, and Her* dazu verführt, ein Prosagedicht über den «Irrgarten» dieser Garderoben, über die Kälte der Geometrie und der Fliesen, über die Grenze von Öffentlichem zu Privatem, über die Verführung ins Reich der Körper zu schreiben.

Diese Wahrnehmungen, diese Stimmen nehmen den Dialog mit einem Werk auf, das durch seine sequenzielle Vielteiligkeit beredt erscheint, doch viele narrative Ansätze gleich wieder bricht, die Betrachter aber durch den Fluß seiner visuellen Sprache mitzieht in ein Nachdenken, letztlich in ein Kreisen um Unsagbares, nicht genau Benennbares ... um Kernpunkte von Existenz: um Ort, Zeit und Identität. Auch der Existenz der Betrachter selbst. Das ist der Zeitpunkt, wo die Betrachter über den eigenen Mut erschrecken.

URS STAHEL

Cabinet of

Cabinet of, 2002, is an installation of 36 C-printed photographs, 28 x 28" each, arranged as a surround on the four walls of a room or in a parallel hanging on opposite walls of a hall.

Cabinet of, 2002, ist eine Installation mit 36 C-Prints, jeder ist 71 x 71 cm gross, als durchgehende Folge entlang der vier Wände eines Raumes angeordnet oder parallel an den gegenüberliegenden Wänden einer Halle.

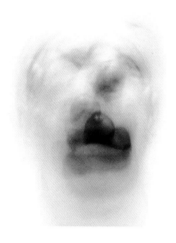
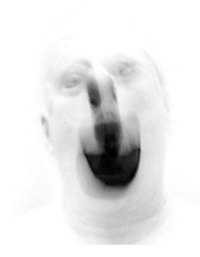

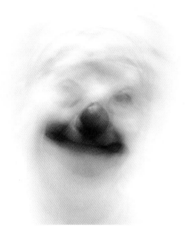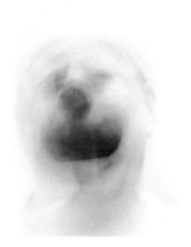

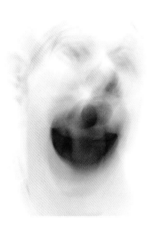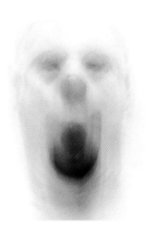

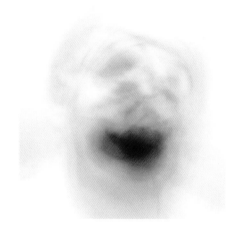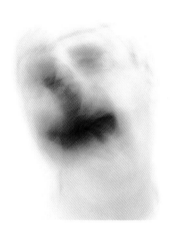

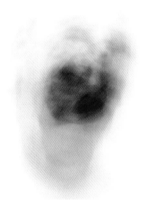 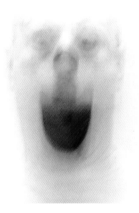

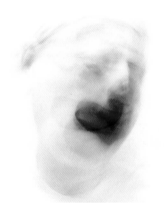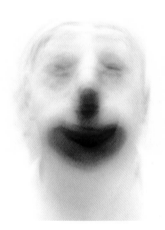

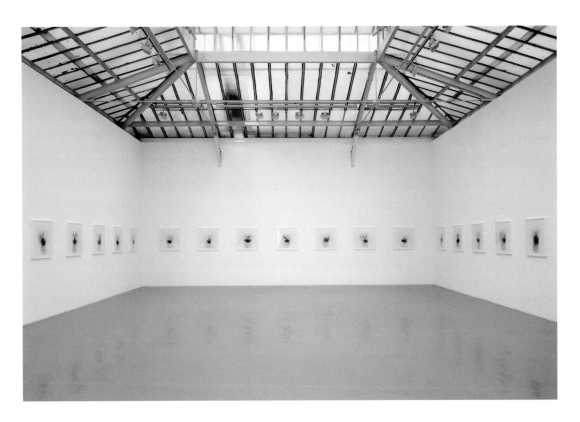

GALERIE YVON LAMBERT, PARIS, 2002

ELISABETH LEBOVICI

IS AN ART CRITIC

LIVING IN PARIS

A Blank

You're talking on the phone, and suddenly the connection is scrambled. The conversation stops. Communication comes to a halt and gives way to silence. Once the voice of the other—so close to your ear just a moment ago—disappears in an incommensurable distance, dim and without an echo, time spreads out a veil of fog.

In everyday language, the color of this suspension is *"blanc"* (white, blank). In French, at least; in English there may be a difference between "white" and "blank," but in French *"blanc"* is not just a color, it is interruption, absence, the retreat of spoken language or discursive thought. Sometimes you see it in images. In a number of paintings by Goya, supernatural clouds of white govern the inexorable horizon beyond the artist's hermits, fugitives, the insane—all those who know neither day nor night. Here white liberates the imaginative powers that accompany unreason.[1] Psychoanalysts use the term "white psychosis" to designate the effect of a "hole in the head … that surpasses its limits; that erases, extinguishes, previous and subsequent ideas and thoughts; that interrupts all connections because there is nothing to be connected."[2] In the modern museum and art gallery, space becomes the "white cube"—considered an empty potential, like Mallarmé's as yet unwritten page, but also readable as its depressive reverse, a "blank space" of muteness. We recognize here a fissure, a "madness under the mask, a madness that eats the face, distorts the features."[3] Here we can read the figure of a kind of doubt that hopefully seizes each of our encounters with art, disconnecting what we already know from what we can feel and perceive.

In any case, it is on the white walls of just such an exhibition space that we see *Cabinet of*—a title arrested in full flight. Thirty-six images, in a square

format, hang side-by-side in a frieze that faces the viewer. The confrontation is hypnotic: a white landscape, a kind of snowlike ether, floods each image, erasing the tangible limits of a figure whom we make out little by little. From image to image it is never the same, this figure without features—leaning to the left or to the right, shown frontally or slightly turned. Inconstant. After a certain period of acclimatization, we begin to think that a blood-red mass in its center may be a face, distorting, retreating, swerving, erasing itself, like the pictorial flesh in a painting by Francis Bacon.

Gilles Deleuze on Bacon: "The entire body escapes through the screaming mouth. Through the round mouth of the pope or the nurse, the body escapes as if it were an artery."[4] The lips, a kiss-red outburst, recall the Joan Crawford of the 1940s.[5] Laughing or grinning, the mouth is a scarlet wound, ensuring the body's eventual disappearance, like the smile of Lewis Carroll's Cheshire Cat: "It vanished quite slowly … ending with the grin, which remained some time after the rest of it had gone."[6] In *Cabinet of* the mocking, almost unbearable smile that survives the disappearance of the body is paired, almost fused, with the appendix of a red fake nose. Grimaces and cosmetics, the moving, changing foundation of a clown's makeup, replace the composition of the face.

Paradoxically—but is it really a paradox?—the makeup dissolves with the surface. The blood-red mass, almost in close-up, brings out the visibility of the image. It also keeps us at a distance, like a glass pane separating the space where the image is created from the real world where the image is visible. "The purpose of rice powder is to conceal all impurities of the skin and to create an abstract unity of the grain and the color of the skin … Although the use of artificial black around the eye and of red to mark the upper part of the jaw follows the same principle, i.e., the need to surpass nature, the result serves an entirely opposite need: the red and the black represent life, a supernatural and excessive life."[7]

No portrait reveals itself in *Cabinet of.* The images exist side-by-side, their variations undoing the model, like an endless, nonhierarchical seismography. None of them reveals a secret that the others would deliberately con-

ceal. There is no beginning, no end, no recognition, just an experience thirty-six times prolonged. The figure is all by itself, without narrative connection to the other figures, "which paradoxically makes it something a bit more than a model: a grammatical subject rather than an actor, the agent—or the figurative or symbolic, respectively strictly formal, agent—of the operation of the image."[8]

The suspended title, *Cabinet of,* offers a first attempt to understand the set of images, through their conditions of exhibition. *Cabinets d'amateurs* (private collections) and curiosity cabinets are worlds designed for the knowledge and pleasure not of the public but of one person; images are called *"de cabinet"* when they have a subject matter reserved for private consumption. *Cabinet of* works the same way, across a plurality of images whose number and scope have nothing to do with the gaze to which they appeal. The images are for one person at a time, panning from one to the next.

The title *Cabinet of* also leads in the direction of cinema, evoking a fragmentary recollection of Robert Wiene's *Cabinet of Doctor Caligari* (1919). In this story of an insane asylum, magic, psychiatry, murder, and somnambulism converge in the made-up face of the actor Conrad Veidt, the hypnotized hero, whose paleness and whose eyes, violently encircled in black, testify not to a tortured intimate psychology but to the film's "demonic" soul.[9] According to the art historian Philippe-Alain Michaud, makeup has been part of the cinematic image since its beginnings,[10] first because of a technical requirement: the body had to be covered with a specific dye to make sure that it captured the light and left an imprint on the film. Symbolically, too, makeup is a necessary mark of transformation. To this day, the application of makeup remains a step the body must undergo in order to become a figure. A touch of makeup on the face is enough for it to enter the spotlight. Yet to make someone up is to deprive the body of interior life, turning it into a mere surface on the screen. In the artificial life of film, makeup invents an "antipsychology" of character. It is not just a technique but a ritual, giving the actor the power to become a figure, and to enter the universe of representations, if masked and with fictional features. This is the passage that *Cabinet of* renders intelligible.

Language corroborates this hypothesis in Roni Horn's previous association of the words "clown" and "cloud."[11] Sharing common Anglo-Saxon roots, these two words intersect in their obsolete spellings, "clowd" and "cloun." Whereas the cloud, in its vaporous, mutable nature, is different in any and all of its repetitions, the clown, on the contrary, is a conventional figure that must always be animated by an actor who, in doing so, gives up his own features and character for a relatively stable stereotype. The visual interference of "clowd" and "cloun" absorbs the traditional photographic genres of portraiture and landscape, which become indistinct, mixing into and transforming themselves. In this way *Cabinet of* produces a visual spoonerism: the artist dissociates the face, capturing it in an endless, changing landscape in which it escapes any fixed memory but also any defined movement. In the chemical bath of the photographic emulsion, *Cabinet of* achieves a fusion of cosmogony and cosmetics.

1 White is virtually a recurring theme in Goya's paintings and miniatures, contaminating, obstructing, and soiling paintings like *Yard of the Fools* (1793–94), *Prison Interior* (1793–94), *Self-Portrait* (1794), *Bandido desnudando a una mujer* (1798–1800), *Gitanos* (1798–1800), and *Casa de locos* (1816). See also the miniatures from the end of the artist's life (1824–25).

2 Jean-Luc Donnet and André Green, "Pour introduire la psychose blanche," in *L'Enfant de Ça,* Paris, 1973, p. 221.

3 "The Goya of the *Casa del Sordo* speaks another madness … the madness of man thrown into his night … a madness under the mask, a madness that eats the face, distorts the features." Michel Foucault, *Histoire de la folie à l'âge classique,* Paris, 1972, p. 295.

4 Gilles Deleuze, *Francis Bacon, Logique de la sensation,* Paris, 1977, p. 23.

5 "The lips are full and sensual; the color runs over the actual outlines just like the lips of Joan Crawford in the 1940s that almost went from one ear to the other." David Bourdon, "Andy Warhol and the Society Icon," in *Art in America,* January/February 1975, pp. 43–44. Quoted by Philippe-Alain Michaud, *Le Peuple des images,* Paris, 2002. See also his program notes for "Maquillage, le visage peint au cinéma," a cycle of films at the auditorium of the Louvre, Paris, in April 2002.

6 Lewis Carroll, *Alice's Adventures in Wonderland,* 1865, chapter 6.

7 Charles Baudelaire, "Eloge de maquillage," in *Le Peintre de la vie moderne,* 1863.

8 Damisch, *L'Amour m'expose,* Paris, 2000.

9 "Caligari opened the era of the 'demonic screen' in 1919." See Siegfried Kracauer, *Die dämonische Leinwand von Caligari zu Hitler,* Frankfurt a. M., 1947.

10 Philippe-Alain Michaud, *Le Peuple des images,* Paris, 2002. See also his program notes for "Maquillage, le visage peint au cinéma," a cycle of films at the auditorium of the Louvre, Paris, in April 2002.

11 See Roni Horn's *Clowd and Cloun (Gray)* and *Clowd and Cloun (Blue),* exhibited at the Dia Center for the Arts, New York, October 2001–June 2002.

ELISABETH LEBOVICI
IST KUNSTKRITIKERIN
UND LEBT IN PARIS

Blank

Du sprichst am Telefon und plötzlich wird die Verbindung unterbrochen. Das Gespräch bricht ab. Der Austausch erlischt, Stille tritt an seine Stelle. Die Zeit breitet einen Nebelschleier aus, wenn die Stimme des Anderen, vor einem Moment noch so nahe an deinem Ohr, in einer unermesslichen Entfernung verschwindet, matt und ohne Echo.

In der französischen Umgangssprache ist «blanc» die Farbe dieser Schwebe. Das Englische unterscheidet zwischen «white» (weiß) und «blank» (leer, blank). Nicht so die französische Sprache: Weiß ist hier nicht nur eine Farbe. Es bezeichnet auch die Unterbrechung, die Abwesenheit, den Rückzug der gesprochenen Sprache oder des diskursiven Denkens. Manchmal beobachtet man dies in Bildern. In einer beträchtlichen Anzahl von Goyas Bildern schweben übernatürliche weiße Wolken über den unerbittlichen Horizont aller Einsiedler, Flüchtenden, Wahnsinnigen, all jener, die weder Tag noch Nacht kennen. Weiß befreit in seinen Bildern die imaginären Kräfte, welche die Unvernunft begleiten.[1] Mit «weißer Psychose» bezeichnet die Psychoanalyse die Auswirkungen eines «Loches im Kopf (...), das seine Grenzen überschreitet, die vorhergehenden und folgenden Repräsentationen und Gedanken ausradiert und auslöscht, die Verbindungen bricht, weil es nichts zu verbinden gibt.»[2] Es ist nicht gleichgültig, daß das Museum und die Galerie für moderne Kunst ihren Raum des «white cube» der Ähnlichkeit mit der noch nicht geschriebenen Mallarméschen Seite geweiht haben.

Aber vielleicht muß man das volle und reine Weiß des modernen Kubus nach dem Maßstab seiner depressiven Kehrseite lesen, jener «blank space», die sonst stumm bliebe. Man erkennt hier den Moment eines Bruchs, eines «Wahnsinns unter der Maske, eines Wahnsinns, der die Gesichter frißt, die Züge verzerrt.»[3] Man könnte hier also die Figur jenes Zweifels hineinlesen, der sich – man würde es hoffen –, jeder unserer Begegnungen mit der Kunst bemächtigt und auflöst, was wir schon wissen, was wir fühlen und wahrnehmen können.

Auf jeden Fall spielt sich *Cabinet of,* ein im vollen Flug angehaltener Titel, auf den weißen Wänden eines Austtellungsraumes ab. 36 Bilder in rechteckigem Format sind Seite an Seite angebracht, in einem Fries, frontal dem Zuschauer gegenüber. Die Konfrontation ist hypnotisch. Eine weiße Landschaft, ein schneeartiger Äther durchflutet jedes Bild, löscht die greifbaren Umrisse einer Figur, die man Stück für Stück auszumachen beginnt. Sie ist nie identisch, diese Figur ohne Züge, die nach links, nach rechts neigt, frontal oder leicht gedreht. Unbeständig. Eine blutrote Masse in ihrer Mitte zeigt, nach einer gewissen Gewöhnungzeit, daß es sich vielleicht um ein Gesicht handelt. Von einem Bild zu anderen verändert die rote Masse ihre Position. Sie verdreht sich, zieht sich zurück, entzieht sich, löscht sich aus wie das bildliche Fleisch auf einem Gemälde von Francis Bacon.

Gilles Deleuze über Bacon: «Der ganze Körper entweicht durch den schreienden Mund. Durch den runden Mund des Papstes oder der Krankenschwester entweicht der Körper wie durch eine Arterie.»[4] Kußrote, überbordende Lippen wie jene der Joan Crawford der 40er Jahre[5], Lachen oder Krampf, die scharlachrote Wunde des Mundes sichert das Verschwinden des Körpers, wie bei Lewis Carrolls Grinsen der Katze von Cheshire. «Sie verschwand sehr langsam ... zuletzt das Grinsen, das noch einige Zeit zurückblieb, nachdem der Rest des Tieres verschwunden war.»[6] Das spöttische, beinahe unerträgliche Grinsen, welches das Verschwinden des Körpers überlebt, findet man hier gepaart, beinahe verschmolzen mit einer roten Pappnase. Grimassen und Kosmetik ersetzen die Komposition des Gesichtes durch den bewegten, wechselnden Grund der Clownschminke.

Paradoxerweise – aber ist es wirklich ein Paradox? – verschmilzt die Schminke hier mit der Bildoberfläche. Die blutrote Masse ist das, was uns, beinahe in Großaufnahme, auf der sichtbaren Ebene des Bildes entgegentritt. Sie hält auch eine Distanz, beinahe wie ein Glas, das die Welt, in der das Bild sich herstellt, vom Umkreis des Realen, in dem wir uns aufhalten, trennt. «Reispuder hat zum Zweck, Hautunreinheiten verschwinden zu lassen und eine abstrakte Einheit des Korns und der Farbe der Haut zu schaffen. … Obwohl der Gebrauch des künstlichen Schwarz, welches das Auge umrundet, und des Rots, das den oberen Teil des Kinns markiert, dem selben Prinzip folgen, dem Bedürfnis, die Natur zu übertreffen, befriedigt das Resultat ein ganz gegenteiliges Bedürfnis. Das Rot und das Schwarz verkörpern das Leben, ein übernatürliches und exzessives Leben …»[7]

In diesem *Cabinet of* enthüllt sich nie ein Porträt. Die Bilder stehen nebeneinander, ihre Variationen lösen das Modell auf, ähnlich einer unendlichen und hierarchielosen Seismographie. Keines enthüllt ein Geheimnis, das die anderen absichtlich verstecken würden. Es gibt keinen Anfang und kein Ende. Kein Wiedererkennen. Nur eine Erfahrung, 36 mal wiederholt. Die Figur ist alleine, ohne narrativen Bezug zu den anderen Figuren, «was sie paradoxerweise zu mehr als einem Modell macht. Eher ein grammatisches Subjekt als ein Schauspieler, der Agent – oder der figurative oder symbolische, d. h. strikt formelle Agent – jener Operation, die das Bild ist.»[8]

Der aufgeschobene Titel, *Cabinet of*, ist ein erster Versuch, die Reihe von Bildern durch ihre Ausstellung zu verstehen. Genau wie alle *cabinets d'amateurs* (Privatsammlungen) oder Kuriositätenkabinette eine Welt zum Genuß und Wissen einer einzigen Person, und nicht eines Publikums, darstellen, sind die Bilder, die mit *de cabinet* bezeichnet werden, aufgrund dessen, was sie zeigen, für den privaten Gebrauch bestimmt. *Cabinet of* bearbeitet dasselbe in einer Pluralität von Bildern, deren Anzahl und das Ausmaß deren Installation nichts zu tun haben mit dem Blick, an den sie sich richten. Die Bilder sind für eine einzige Person aufs mal da, in einer langsamen Kamerabewegung von einem zum anderen. Die Bezeichnung *Cabinet of* führt auch auf die Spur des Kinos, indem sie wie eine fragmen-

tarische Erinnerung auf *Das Kabinett des Dr. Caligari* (1919) verweist. Eine Geschichte eines Irrenhauses, wo Magie, Psychiatrie, Mord und Schlafwandeln im geschminkten Gesicht des Schauspielers Conrad Veidt zusammentreffen, dem hypnotisierten Helden, dessen bleiches Gesicht und dessen mit heftigem Schwarz umrandete Augen nicht von einer gequälten persönlichen Psychologie zeugen, sondern von der dämonischen Seele des Filmes.[9]

Gemäß dem Kunsthistoriker Philippe-Alain Michaud[10] sind Schminke und das filmische Bild miteinander verbunden seit den Anfängen des Kinos. Die Schminke gehört zum Wesen des fiktiven Filmes. Zuerst durch ein technisches Erfordernis: Der Körper muss mit einer gewissen Farbe bedeckt werden, damit er das Licht einfängt und auf dem Film eine Spur hinterlässt. Gleichzeitig ist die Schminke auf einer symbolischen Ebene das Zeichen einer obligatorischen Verwandlung. Auch heute ist «geschminkt werden» ein Schritt, der dem Körper auferlegt wird, damit er Figur werde. Eine Spur Schminke auf dem Gesicht genügt, und er kann seinen Auftritt unter den Scheinwerfern machen. Das Schminken ist jene Operation, durch die der menschliche Körper seine Innerlichkeit verliert, Leinwand wird, eine bloße Oberfläche. Im künstlichen Leben des Films erfindet die Schminke eine «Anti-Psychologie» der Rolle. Es handelt sich dabei nicht nur um eine Technik, sondern auch um ein Ritual, das dem Menschen die Macht verleiht, sich in eine Figur zu verwandeln und maskiert, mit fiktiven Zügen, ins Universum der Darstellungen einzugehen. Es ist dieser Übergang ins Bild, den *Cabinet of* sichtbar macht.

Die Sprache bestätigt diese Annahme in Roni Horns Assoziation der verwandt klingenden Worte «clown» und «cloud». Mit imaginären gemeinsamen Wurzeln versehen durchdringen sie sich im Wortspiel «clowd and cloun». Obwohl die Wolke durch ihre dunstige und wechselhafte Natur die Differenz in jeder ihrer Wiederholungen hervorruft, stellt der Clown im Gegenteil eine konventionelle Figur dar, die immer von einem Schauspieler zum Leben erweckt werden muß, der wiederum seine eigenen Züge und seine eigene Psychologie zugunsten eines verhältnismäßig stabilen Stereotyps verliert. Die visuelle Interferenz von «clowd» und «cloun»[11] hebt die

traditionellen fotografischen Genres von Porträt und Landschaft auf, die sich verwischen, mischen, sich verwandeln. *Cabinet of* produziert einen visuellen Schüttelreim. Roni Horn dissoziert so ein Gesicht in einer unbegrenzten und bewegten Landschaft, wo es jeder festen Erinnerung entflieht, aber auch jeder fest umrissenen Bewegung. *Cabinet of* verschmilzt im chemischen Bad der fotografischen Emulsion Kosmogonie und Kosmetik.

1 In den Gemälden und Miniaturen des spanischen Künstlers Francisco Goya ist Weiß ein wiederkehrendes Thema, das Bilder, wie *Hof der Narren* (1793–94), *Gefängnisinneres* (1793–94), *Selbstportät*, (1974), *Bandido desnudando a una mujer* (1798–1800), *Gitanos* (1798–1800), *Casa de Locos* (1816), verschmutzt, verstellt und verdreckt. Siehe auch die Miniaturen, die der Maler am Ende seines Lebens schuf (1824–25).

2 Jean-Luc Donnet und André Green, «Pour introduire la psychose blanche», in *L'Enfant de Ça*, Paris, 1973, S. 221.

3 «Der Goya des *Hauses der Tauben* spricht von einem anderen Wahnsinn (...) einem Wahnsinn unter der Maske, einem Wahnsinn, der das Gesicht frißt, die Züge verzerrt.» So beschreibt es Michel Foucault in *Histoire de la folie à l'âge classique*, (1. Ausgabe, 1961), Paris, Ed. 10/18, 1972, S. 295.

4 Gilles Deleuze, *Francis Bacon, Logique de la Sensation*, Paris, 1977, S. 23.

5 «Die Lippen sind voll und sinnlich, die Farbe überschreitet die natürlichen Umrisse, wie die Lippen der Joan Crawford in den 40er Jahren, die beinahe von einem Ohr zum anderen gingen.» David Bourdon, «Andy Warhol and the Society Icon», in *Art in America*, Januar/Februar 1975, S. 43–44. Zitiert von Philippe-Alain Michaud.

6 Lewis Carroll, *Alice im Wunderland*, Kapitel 6.

7 Charles Baudelaire, «Eloge de Maquillage», in *Le Peintre de la Vie Moderne*, Paris, 1863.

8 Damisch, *L'Amour m'expose*, Paris, 2000.

9 «Caligari eröffnete 1919 das Zeitalter der ‹dämonischen Leinwand›.» Siehe Siegfried Kracauer, *Die dämonische Leinwand von Caligari zu Hitler*, Frankfurt a. M., 1947.

10 Philippe-Alain Michaud, *Le Peuple des images*, Paris, 2002, und seine Bemerkungen zu «*Maquillage, le visage peint au cinéma*», einem Filmzyklus im Auditorium des Louvres im April 1997.

11 Siehe *Clowd and Cloun (Gray)* und *Clowd and Cloun (Blue)*, zwei Arbeiten von Roni Horn, ausgestellt in der Dia Art Foundation, Oktober 2001 bis Juni 2002.

Another Water

(The River Thames, for Example)

Another Water (The River Thames, for Example), 2000, is a book, 112 pp., published by Scalo, Zurich. Fifty photographs of the surface of the River Thames in the Central London area are interspersed with dead body reports. All are annotated with footnotes running in an unbroken ribbon at the bottom of each page and from cover to cover.

A closely related work, *Still Water (The River Thames, for Example)*, 1997–1999, is an installation of fifteen footnoted photographs printed on uncoated paper. $30\,^1/_2$ x $41\,^1/_2$"each.

Another Water (The River Thames, for Example), 2000, ist ein Buch, 112 Seiten, erschienen bei Scalo, Zürich. Fünfzig Fotografien der Oberfläche der Themse, dazwischen Polizeireporte über Leichen im Fluß. Alle sind mit Fußnoten versehen, die in einem ununterbrochenen Band am unteren Seitenrand von Buchdeckel zu Buchdeckel laufen.

Still Water (The River Thames, for Example), 1997–1999, ein eng verwandtes Werk, ist eine Installation von fünfzehn Fotografien mit Fußnoten, gedruckt auf Papier ohne Lack. Je 77.5 x 105.5 cm.

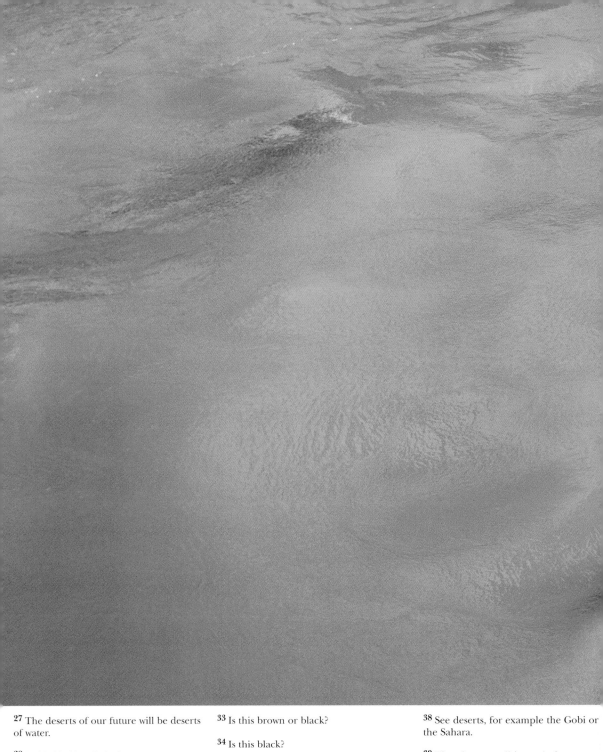

27 The deserts of our future will be deserts of water.

28 Is this khaki or beige?

29 Is this beige or ochre?

30 Is this ochre or yellow?

31 Is this yellow or tan?

32 Is this tan or brown?

33 Is this brown or black?

34 Is this black?

35 Under the cover of ugly, evasive colors, black is constant. These useless, hopeless colors coagulate around this black place.

36 What does water look like? [37]

37 See sand. (Especially sand dunes.) [38]

38 See deserts, for example the Gobi or the Sahara.

39 There's a story (it's true) about a ma traveling by tube to Westminster Bridge handcuffed to a chair. He threw himself the river with the chair. He was found some days later downstream attached to stick of wood and a section of naugahyc (almond-colored).

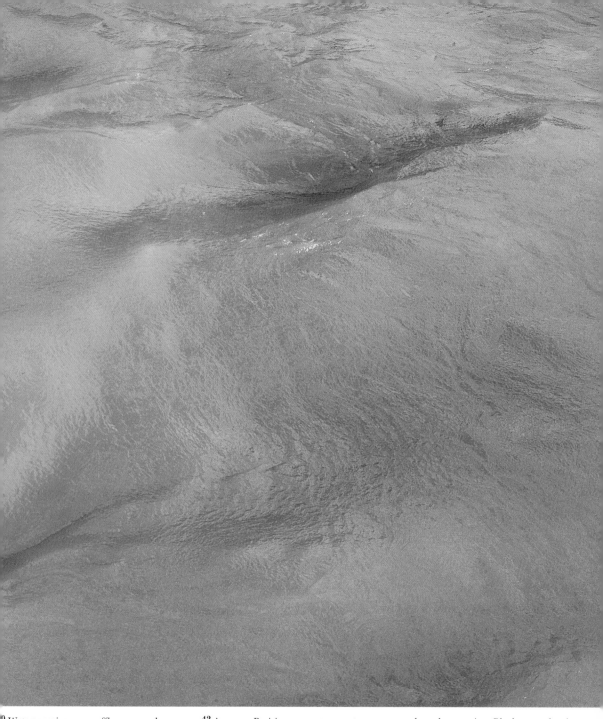

Water receives you, affirms you, shows [y]ou who you are. And all the near-[im]perceptible qualities that are water tease [y]ou with their ambiguity. Tease you and [e]xtend you, out into the world.

[4]¹ The Thames has the highest rate of [s]uicides of any urban river. Maybe it's not [t]he highest but it's close. It doesn't really [m]atter because even if it doesn't, it *looks* [li]ke it does.

42 A young Parisian woman came to London recently to drown herself in the river. It's curious how the Thames attracts people from far away. I've never heard of any other river doing this. (Usually it's just the locals.) I mean people don't travel from Canada to kill themselves in the Hudson — or even from Ohio.

43 Black water is opaque water, toxic or not. Black water is always violent. Even when slow-moving. Black water dominates, bewitches, subdues. Black water is alluring because it is disturbing and irreconcilable. Black water is violent because it is alluring and because it is water.

45 When water moves rapidly (and in unpredictable ways) it intensifies its darkness.

46 Darkness reflects the sun. Blackness reflects nothing.

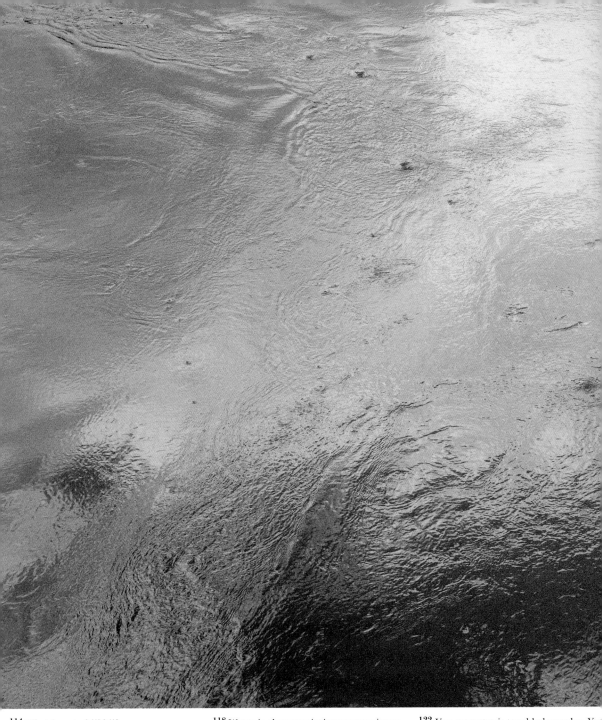

114 What is water? [115 & 116]

115 Mock or mirror?

116 Mirror or me?

117 A man yet to be identified was found in the river last week. The body was lying in a fetal position on the foreshore of Upper Pool. His ankles were bound, and the rope was attached to his waist.

118 Water is always an intimate experience, even as rain or ocean or river.

119 Water is always an intimate experience; you can't separate yourself from it.

120 Water is always a personal experience; your relationship to water is your relationship to yourself.

121 When you say water, what do you mean?

122 You say water is troubled or calm. You say water is rough and restless. You say water is disturbed. You say water is quiet. Water is serene and sometimes clear, it might be pure and then it is brilliant. Water is heavy; that's a fact. Water is often tranquil, even placid. Water is still and then it might be deep as well. Water is cold or hot, chilly or tepid. You say water is brash or brisk, sometimes crisp. You say water is soft and hard. You say water irritates and lubricates. You say water is

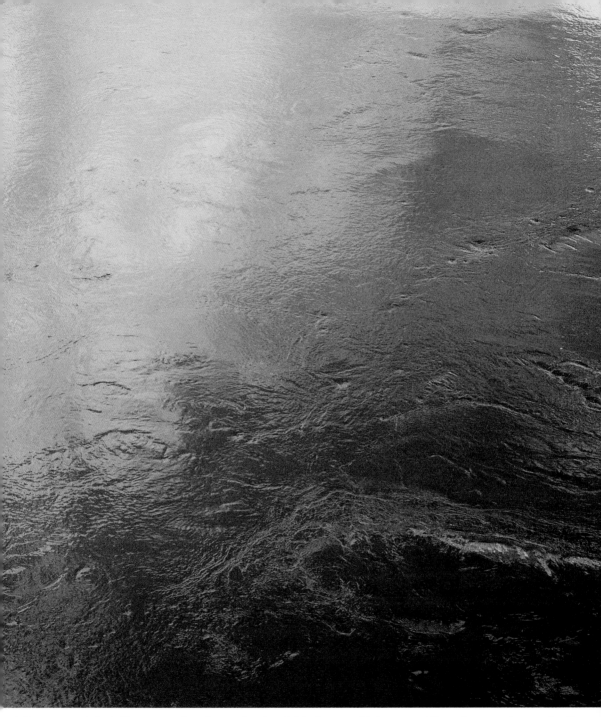

oul. You say water is fresh. You say water is
mpid and languorous. You say water
s sweet.

23 Black water is never sweet. Black water
s cold, often frigid, sometimes cool but
ever tepid. Black water is hard not soft.
t's brash and rough; it might irritate; it
till lubricates. It's often disturbed but it's
ever calm, at least not simply calm. It
night be fresh, but you'd never know it
nd I'm sure you'd never believe it. It's

frequently agitated. It's always troubled.
I don't think you can question that, even
when it appears quiet. Black water is never
serene or brilliant or clear. It's unsettled,
even when still. It can be deep, but it's
hard to know where. Even black water is
wet, but mostly in a parching way.

124 This photograph is an image of a
moment on the Thames. It is also a
moment similar to other moments of
moving water and especially moments of

rapidly moving water that were hardly
visible. But you extrapolate from your
experience, you recognize things you've
never actually seen — things that simply
weren't visible. You recognize things
you've never actually seen — even though
you may have watched them as you may
have watched this river for hours at a time.
But you know it's a river, water moving
from here to there. You feel like you've
seen it before. But you haven't, what
you've actually seen is a slur: the form a

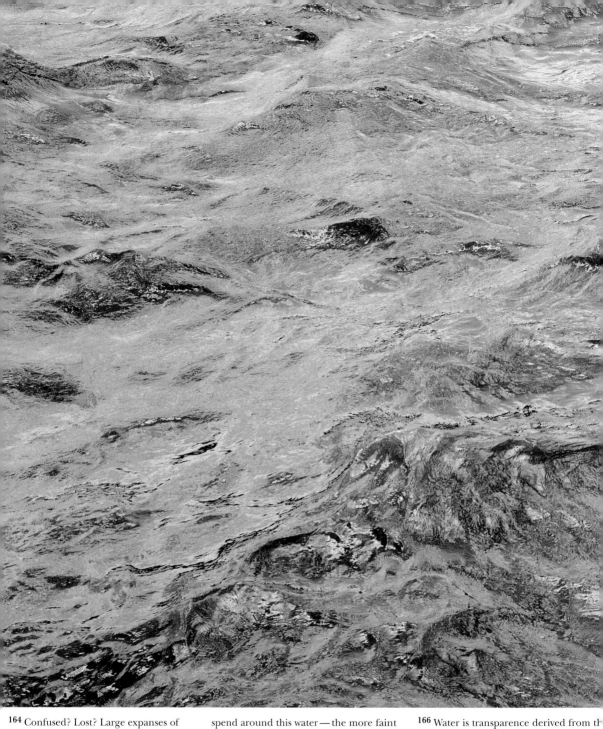

164 Confused? Lost? Large expanses of water are like deserts; no landmarks, no differences to distinguish here from there. (If you don't know where you are, can you know who you are?) Just tumult everywhere, endlessly. Tumult modulating into another tumult all over and without end. The change is so constant, so pervasive, so relentless that identity, place, scale—all measures lessen, weaken—eventually disappear. The more time you spend around this water—the more faint your memories of measure become.

165 Water is a mysterious combination of the mysterious and the material. Imagine something that, impinged on by everything in contact with everything, remains to this day mostly transparent—even crystal clear, when taken in small enough quantities.

166 Water is transparence derived from the presence of everything.

167 Water is transparence derived from the presence of everything. That is water sifted down, filtered out through the planet Earth, earth—aquifer that clarifie and realizes purity. This filter of everything modulates to exquisite balance a substance is obtained that bears no likeness. All things converge in a single identity: water.

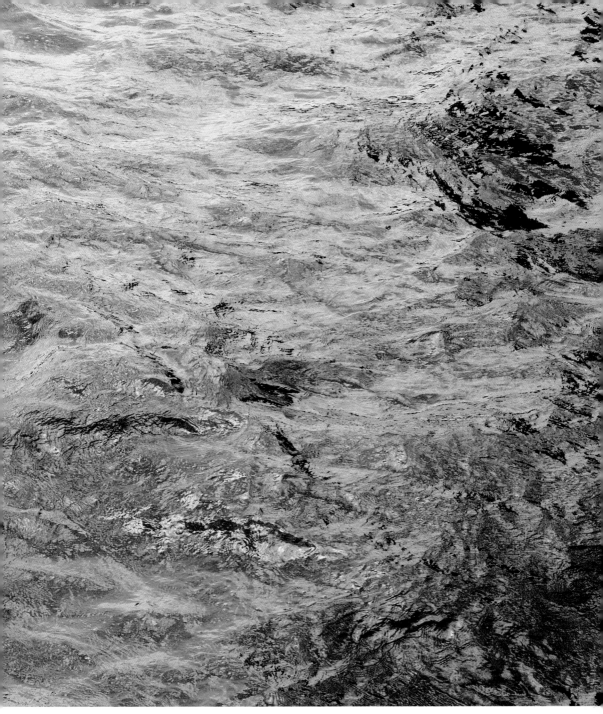

68 Water is utopic substance.

69 Water's always a reflection of local circumstance — the whole of it: geology, economics, politics, religion and so on. Eventually, everything finds its way into the river.

70 Among water? Isn't water a plural form? How could it ever be singular, even in one river? Where did that water come from?

171 Which river did Neil Young shoot his baby down by? [172]

172 See the song "Down by the River" ("Down by the river, I shot my baby...I shot her dead...."), written by Neil Young, from the album *Everybody Knows This Is Nowhere,* 1969. (The river is not identified in the song.)

173 (Did you kill your baby down by the river? Did you kill your babies down by the river? Did you get your baby pregnant down by the river? What did you do down by the river?)

174 Water, I imagine even the Thames, verges on invisibility when taken in small enough quantities. In greater quantities it acquires visibility, like air; some things only acquire visibility in depth. (But does this visibility obscure sight or extend it?)

175 So speaking of the Thames, I took a

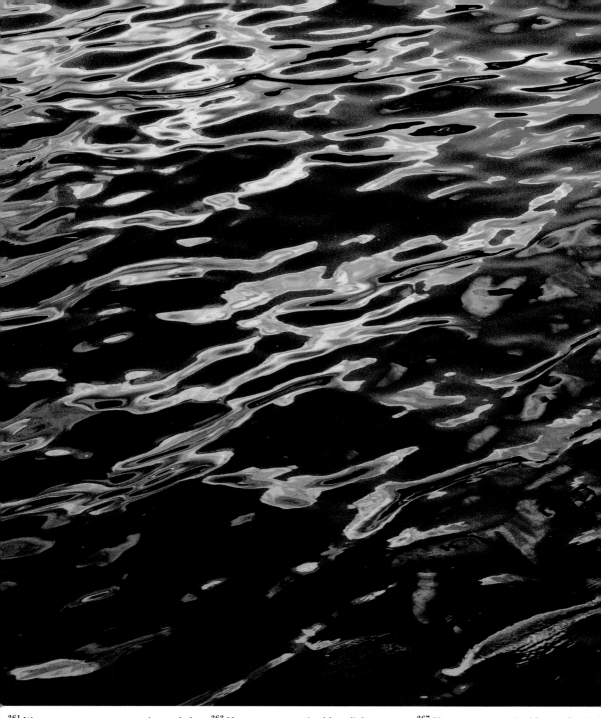

361 Water: your water, my water is coupled water. Water is never only a form, it's a relation, too. The form, for example: liquid. The relation: water's indivisible connection to all things, superficially with inanimate things, intimately with living things.

362 (Water is the master verb: an act of perpetual relation.)

363 Have you ever noticed how light camouflages water?

364 Have you ever noticed how rarely water looks like water?

365 What does water look like? [366]

366 See military camouflage. For example: "Polish Presidential," "Italian Woodland," "San Marco Mediterranean," "Indonesian Spot," and "Belgian Jigsaw" patterns.

367 Have you ever noticed how reflection on the water at night make water look more watery?

368 Sometimes, in a quiet area, the water soft and delicate-feeling: an easier entrance beguiling you.

369 When you look at water, you see what you think is your reflection. But it's not yours. (You are a reflection of water.)

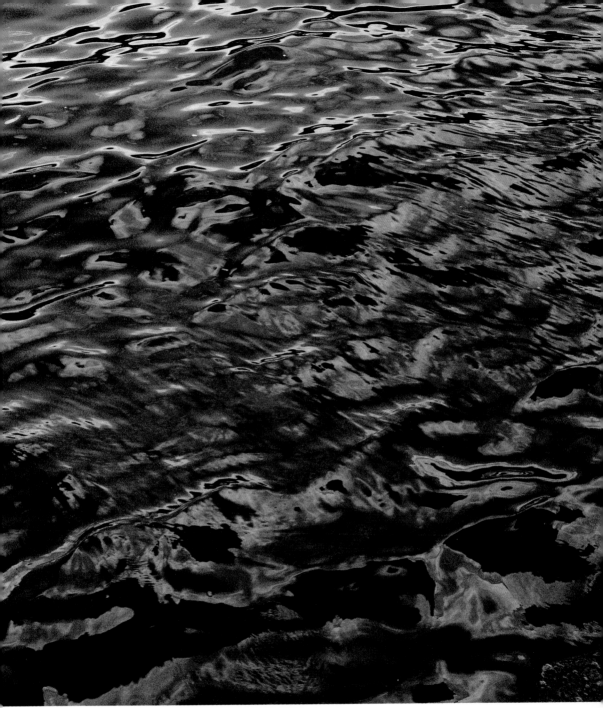

70 Have you ever noticed how light reflections on the water sometimes look like camouflage?

71 Every year they find a body or two in the river that remain unidentified.[372]

72 Isn't that what you'd expect? Isn't that what you'd be after — to lose your identity? (The Thames looks like a solvent for identity, doesn't it?)

373 Which river did Jimi Hendrix shoot his baby down by? [376] Maybe it wasn't a river, but it seems like it should have been. (When I'm in Basel I'm certain it's the Rhine, the fastest, most furious thing in town.)

374 See the song "Hey Joe" ("I'm going down to shoot my old lady, you know I caught her messin' round with another man. . . . "), written by Billy Roberts and recorded by Hendrix in 1967.

375 "Take me to the river, drop me in the water." [376 & 377]

376 (In the Thames that would be murder.)

377 See the song "Take Me to the River," written by Al Green and Mabon Hodges.

378 A congress of starlight-like specks, bubbles, infinitesimal rainbows, and finely (though quickly) wrought reflections—

BELL HOOKS
IS A WRITER
LIVING IN NEW YORK

The abyss of surrender in another water

Water fascinates us from birth on. One of the fluids that sustains life, it is also able to take life, to suck us down and hold us. It brings a return to the wilderness of the womb with a vengeance. The healing, life-sustaining properties of water do not change the fact that it is also a wild assassin, alluring to the soul yet capable of endless betrayal. These are the paradoxical dimensions of water that Roni Horn captures in *Another Water*, an installation of images and words.

No body of water has embodied the sense of wet threat as much as the River Thames. Unlike other dangerous bodies of water in the world, it has a seductive lure that begins with the recognition of it as shadowy dark, not the clear water of baptism, not holy. If the Thames is sacred, it is only because we come to it knowing that to stare into its depths is to encounter the abyss. Our flirtation with the Thames involves just this human longing to overcome our fear of the abyss, of death, since an abyss by definition evokes the space

of the mysterious and calls forth the unfathomable. And what is the divine allure of darkness and death if not their promise to return us to an original state of oneness with the elements, with nature?

Writing on the properties of water and darkness combined, Gretel Ehrlich shares this insight in her book *This Cold Heaven: Seven Seasons in Greenland*: "Early Greek theories held that vision resulted from particles continually streaming off the surface of bodies, or that the way was made of water … Darkness reconciles all time and disparity. It is a kind of rapture in which life is no longer lived brokenly. In it we are seers with no eyes." The Thames offers a bond without brokenness as we witness the commingling of water and dark. Horn's images not only document this union, they interrogate it, revealing, exposing, and sometimes staging the best of all cover-ups by merely staying on the surface, refusing the abyss even as they capture its life, the various shapes, moods, and colors that call us to surrender, to give ourselves over to that which cannot be known but only witnessed, received but never contained.

Horn parts the waters keenly so that we may better understand that mystery must be maintained. The world of unknowing cannot be penetrated, and indeed must be cherished if our fragile brokenness is to be borne without continual, meaningless conflict and resistance. Horn's humor and witty eye, her shrewd, relentless searching for hidden narratives, show that all those who seek to lose themselves in the watery depths of the Thames end up bringing themselves out of the shadows into light. Hence the accounts she offers of the seekers who have come to throw themselves into the abyss, only to be thrown up, back, forward. She writes, "Disappearance; that's why suicides are attracted to it. It's also why children fear it … When I imagine the river, it's something I can enter, something that will surround me, take me away from here." Yet the Thames repudiates this projection, refusing to be the place in which all can be let go and lost.

Horn offers us an interior glimpse of "another water" that beckons us into greater visibility, and therefore into the nirvana of being known in our brokenness. Her images embrace the shadow. Compelling us to move past

the one-dimensional notion of black water as emblematic always and only of death, she offers us the opaque darkness that is living water, an abyss of surrender in whose depth the soul can merge and be restored. These are not the still waters of bliss. The work is a record of turbulent movement, of the soul groping toward the recognition that we must run on as the river runs, accepting that the mystery of death and resurrection cannot be contained by simplistic projections and explanations. Calling to life "another water," these images make the eye remember that in the abyss of surrender we find the soul's code revealed.

BELL HOOKS
IST SCHRIFTSTELLERIN UND
LEBT IN NEW YORK

Der Abgrund, sich einem anderen Wasser zu ergeben

Wasser fasziniert uns von Geburt an. Als eine der Flüssigkeiten, die Leben erhalten, kann es auch Leben nehmen, uns nach unten reißen und festhalten. Es bringt eine gewaltige Rückkehr in die Wildnis der Gebärmutter. Die heilenden, lebenserhaltenden Eigenschaften des Wassers ändern nichts daran, daß es auch ein wilder Mörder ist, die Seele anziehend, doch fähig zu endlosem Verrat. Dies sind die paradoxen Dimensionen des Wassers, welche die Künstlerin Roni Horn in *Another Water*, einer Installation in Bildern und Worten, erfaßt.

Kein anderes Gewässer hat das Gefühl der feuchten Bedrohung so sehr verkörpert wie die Themse. Im Gegensatz zu anderen gefährlichen Gewäs-

sern dieser Welt hat sie einen verführerischen Reiz, der mit der Erkenntnis beginnt, daß sie schattenschwarz ist, nicht das klare Wasser der Taufe, nicht geweiht. Wenn die Themse denn heilig ist, dann nur, weil wir zu diesem Wasser kommen im Wissen, daß in seine Tiefen zu starren eine Begegnung mit dem Abgrund ist. Unser Flirt mit der Themse beinhaltet denn auch jene Sehnsucht der Menschen, unsere Furcht vor dem Abgrund, dem Tod, zu überwinden, da ein Abgrund definitionsgemäß den Raum des Geheimnisvollen heraufbeschwört und das Unergründliche anruft. Und worin besteht die göttliche Anziehung der Dunkelheit und des Todes, wenn nicht in deren Versprechen, uns in einen ursprünglichen Zustand der Einheit mit den Elementen, mit der Natur, zurückzuführen?

Gretel Ehrlich schreibt über die Eigenschaften von Wasser und Dunkelheit in *This Cold Heaven: Seven Seasons in Greenland:* «Die frühen griechischen Theorien gingen davon aus, daß das Sehen von Partikeln rührt, die unablässig von der Oberfläche der Körper ausströmen, oder daß deren Weg aus Wasser besteht ... Dunkelheit versöhnt alle Zeit und alle Ungleichheit. Sie ist eine Art von Taumel, in dem das Leben nicht länger gebrochen gelebt wird. In ihr sind wir Seher ohne Augen.» Die Themse bietet einen Bund ohne Bruch an, da wir Zeugen der Vermischung von Wasser und Dunkelheit werden. Horns Bilder dokumentieren diese Verbindung nicht nur, sie untersuchen, enthüllen sie, legen sie frei und inszenieren manchmal das beste Vertuschungsmanöver, indem sie an der Oberfläche bleiben, den Abgrund abweisen, obwohl sie sein Leben einfangen, die verschiedenen Formen, Stimmungen und Farben, die uns zur Kapitulation auffordern, uns dem auszuliefern, was nicht gewußt werden kann, nur erfahren, das empfangen, aber nie gefaßt werden kann.

Scharfsichtig teilt Horn die Wasser, damit wir besser verstehen können, daß das Geheimnis erhalten bleiben muß. Die Welt des Nichtwissens kann nicht durchdrungen werden, und wir müssen sie in der Tat wertschätzen, wenn wir unsere zerbrechliche Gebrochenheit ertragen sollen ohne ständigen, sinnlosen Konflikt und Widerstand. Horns Humor und geistreiches Auge, ihr gerissenes, unablässiges Suchen nach verborgenen Narrativen,

zeigen, daß all jene, die sich in den wässerigen Tiefen der Themse zu verlieren suchen, sich am Ende doch aus dem Schatten ans Licht bringen. Daher der Bericht, den sie bietet über jene Suchenden, die kamen, um sich in den Abgrund zu stürzen, um wieder ausgespuckt zu werden, zurück, vorwärts. Sie hält fest: «Verschwinden; das ist die Weise, in der Selbstmörder von ihm angezogen werden. Das ist, weshalb Kinder es fürchten ... Wenn ich mir den Fluß vorstelle, ist er etwas, in das ich steigen kann, etwas, das mich umgeben wird, mich von hier wegführen wird.» Und trotzdem weist die Themse diese Projektion zurück, weigert sich, der Ort zu sein, in dem alles losgelassen und verloren werden kann.

Horn bietet uns eine Innenansicht eines anderen Wassers, das uns in eine größere Sichtbarkeit lockt und somit ins Nirwana des Erkanntwerdens in unserer Gebrochenheit. Ihre Bilder umarmen den Schatten. Indem sie uns zwingt, die eindimensionale Dimension des schwarzen Wassers als emblematisches Immer und Nur des Todes hinter uns zu lassen, bietet sie uns die undurchsichtige Dunkelheit an, die das lebende Wasser ist, ein Abgrund des Sich-Ergebens, in dessen Tiefe die Seele schmelzen und wiederhergestellt werden kann. Dies sind nicht die stillen Wasser der Seligkeit. Die Arbeit ist ein Zeugnis turbulenter Bewegung, jener der Seele, die sich an die Erkenntnis herantastet, daß wir fließen müssen, wie der Fluß fließt, und daß wir akzeptieren müssen, daß die Geheimnisse von Tod und Auferstehung nicht durch vereinfachende Projektionen und Erklärungen erfaßt werden können. Indem diese Bilder ein anderes Wasser *(Another Water)* ins Leben rufen, lassen sie das Auge sich erinnern, daß wir im Abgrund des Sich-Ergebens den Code der Seele enthüllt finden.

This is Me, This is You

This is Me, This is You, 1997–2000, is an installation of 48 paired photographs (96 total), 10 ³/₄ x 13" each. One member of each of the 48 pairs is composed into one of two complementary panels of individually framed images. Each panel is placed on opposite walls or from room to room. Overall size of each panel is approximately 11 x 9".

This is Me, This is You, 2001, is a book of 50 paired photographs (100 total). One member of each of the pairs is sequenced into complementary books. The two volumes are bound back to back forming a book without end—a book that leads the viewer back and forth in a delayed swing between paired images.

This is Me, This is You, 1997–2000, ist eine Installation von 48 Paaren von Fotografien (96 total), je 33 x 27.3 cm. Jede Hälfte jeden Paares ist in einem entsprechenden Feld von einzeln gerahmten Bildern angeordnet. Die beiden Gruppen befinden sich an gegenüberliegenden Wänden oder in verschiedenen Räumen. Jede Gruppe hat eine Gesamtfläche von ungefähr 4.5 x 5.5 m.

This is Me, This is You, 2001, ist ein Buch mit 50 Paaren von Fotografien (100 total). Jede Hälfte jeden Paares findet sich in gleicher Reihenfolge in den beiden Büchern, die Rücken an Rücken gebunden sind und ein Buch ohne Ende bilden – ein Buch, das den Betrachter verzögert zwischen den Bildpaaren hin und her pendeln lässt.

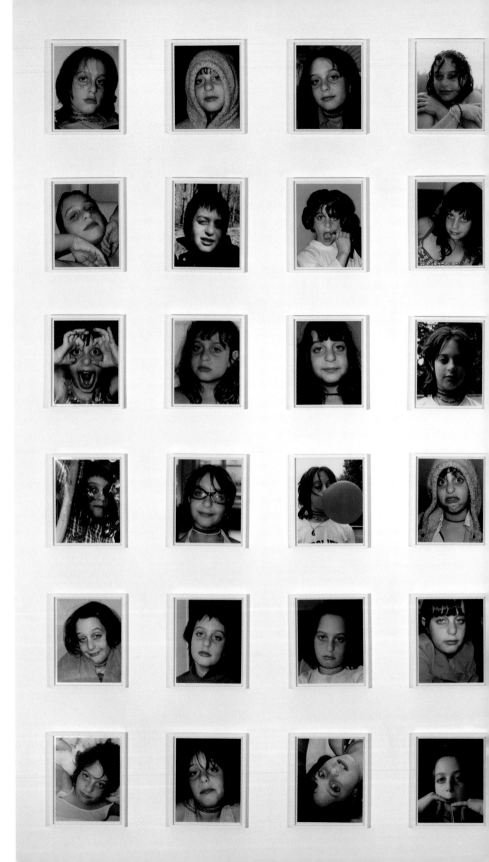

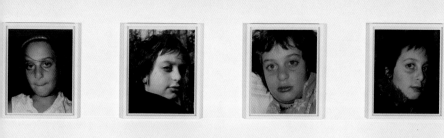
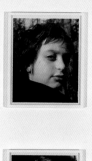
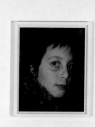
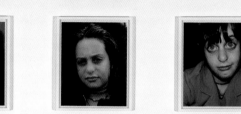
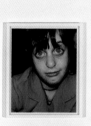
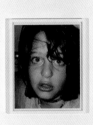
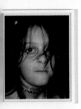
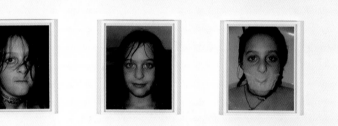
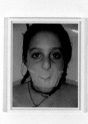
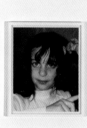
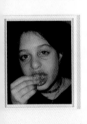
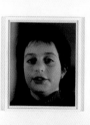
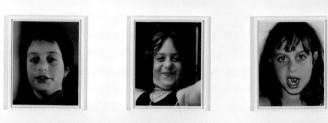
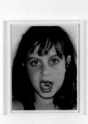
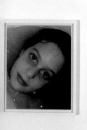
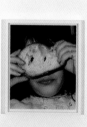
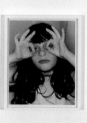
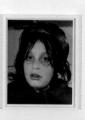
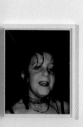
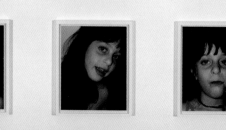
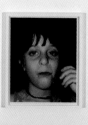
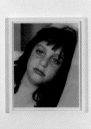

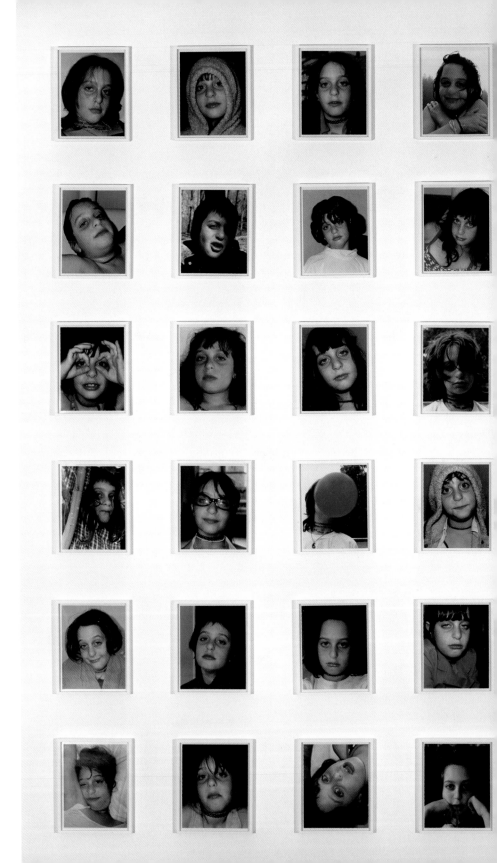

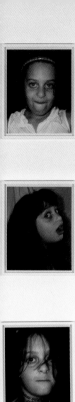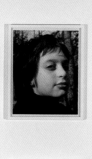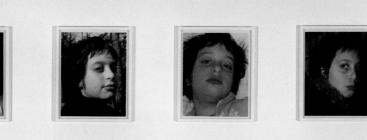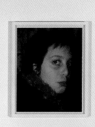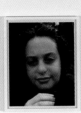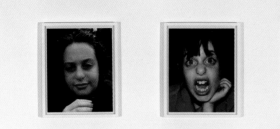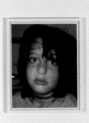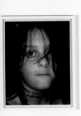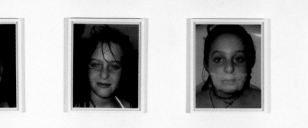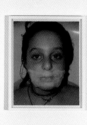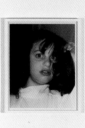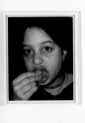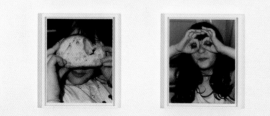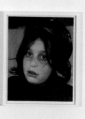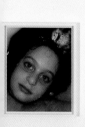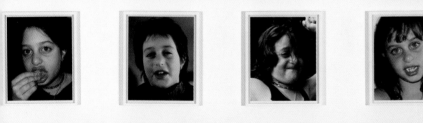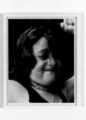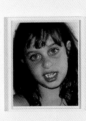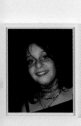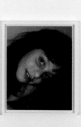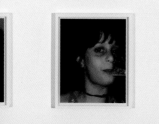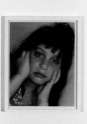

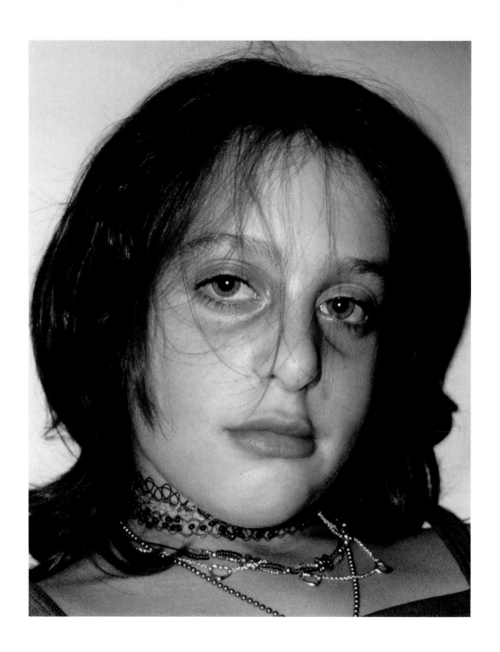

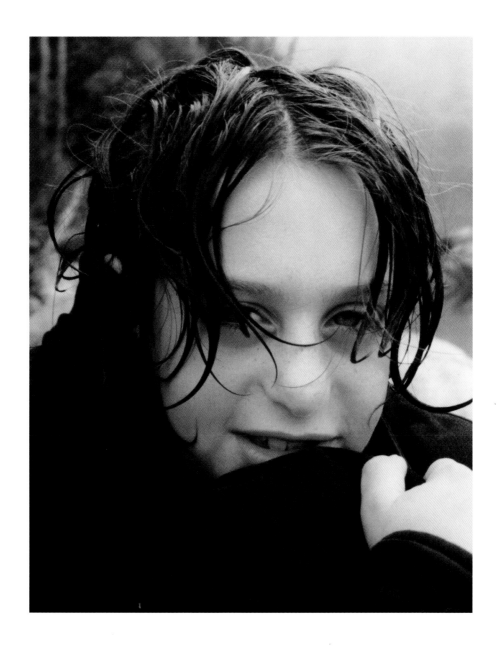

THIERRY DE DUVE
IS AN ART HISTORIAN AND A PHILOSOPHER
LIVING IN BRUSSELS

This is Me, This is You

Abandoned, absorbed, acting, adolescent, adorable, angry, appalled, assertive, bad, beautiful, bejeweled, bereaved, bespectacled, bewildered, biting on a muffin, blasé, blowing a balloon, boyish, camera-conscious, candid, capricious, charming, chewing gum, childish, comic, confiding, coquettish, couldn't-care-less, cross, cunning, cute, defiant, determined, disdainful, dishevelled, dressed up, drinking from a straw, eating salad, emerging from the shower, expectant, facetious, facing you, falsely imploring, fat, fed up, feminine, flirtatious, frowning, giving you the look, glamorous, glum, graceful, graceless, grinning, grotesque, grown up, happy, here, hooded, horrified, immature, impassive, impish, in her role, ingénue, in love, in the know, incredulous, inquiring, intelligent, ironic, Jewish mother, Jewish princess, lazy, long-haired, lost, lovely, loving, ludicrous, luscious, lush, lying in the bathtub, making faces, mature, mischievous, mistrustful, mocking, monkey, moody, morose, motherly, mute, mutinous, naïve, natural, naughty, never giggling, obliging, oblivious, open, ordinary, out of her role, perplexed, playful, playing hide and seek, plump, pondering, posh, posing, pouting, preoccupied, present, pretending, pretty, proud, purposive, pushy, putting on an act, rarely caught unaware, relaxed, resilient, roguish, romantic, Sabra, sad,

sceptical, seductive, self-confident, self-conscious, sensuous, serious, sexy, short-haired, shouting, shy, sly, smart, smiling, sorry, spontaneous, star, staring, street-wise, sweet 'n' sour, sweet, talkative, there, tongue-in-cheek, tragic, triumphant, twisting her hair, ungrateful, upside down, vamp, versatile, vexed, wet, whimsical, wigged, withdrawn, womanly, yielding, zany.

The above list of adjectives is a poor attempt at describing the changing features and the range of expressions of Georgia Loy as she moves from childhood into full-blown adolescence in Roni Horn's photographs, taken over a two-year period, composing *This is Me, This is You*. Georgia Loy is the artist's niece, and she contributed the title. The work exists both for the wall and as a book. The book comprises two times fifty "paired images," the wall installation two times forty-eight. The images in each pair were taken a few seconds apart. In the gallery setting, one set of images forms a grid on the wall of one room while the other hangs in a similar arrangement on the wall of another room. The images are paired by their identical placement on the two grids, respectively. At first glance you have the impression that you are presented with the same work shown twice. Once you have noticed the pairing, though, you find yourself spotting a particular photograph and keeping it in mind while running to the other room to check its counterpart, shuttling back and forth between the two rooms, again and again. The exercise is both exhilarating and frustrating, as if the artist had wanted you to enact in your body movements the fleeting difference between each of the two snapshots. Time becoming space. The book is actually two books glued together back to back, soft-covered and slipped into a simple casing, with the photos printed full-page on the right side of each double page, on pliable paper. The images are paired by their identical ordering in the two books, respectively. The resulting object is a familiar and yet baffling flipbook. There is no sense of chronology as you flip through the pages: the girl doesn't grow older, her mood doesn't evolve, her demeanour doesn't follow a pattern. Nor is there any sense of "before and after" when you clumsily try to match the paired images, with a finger of either hand marking the page in either book. "Thwarting the narrative is an important way to engage people's interest,"

the artist has said. Indeed. Every photo of the girl is self-contained, and every single one is a beginning, like the first lines of Emily Dickinson's poems which Roni Horn borrowed in *Key and Cues*. The photographs are more landscape than portrait. What the artist has said of Iceland befits the girl: "Iceland is always becoming what it will be, and what it will be is not a fixed thing either. So here is Iceland: an act, not an object, a verb, never a noun." Georgia Loy is a verb. Trying to circumscribe a verb with the help of adjectives is a doomed endeavor.

Why not start all over again, from elsewhere? The girl is quite something. A strong personality, no doubt. And those eyes! Turquoise, now blue now green, clear as water yet enigmatically opaque, wide open most of the time, sparkling with intelligence and unbelievably receptive. More receptive, that is, than expressive, although they are expressive too. Georgia simply revels in the loving attention paid to her by her aunt. Her gaze innocently absorbs and knowingly reflects the fact—nothing more than the mere fact, but one steeped in care and desire—that she is being looked at through Roni Horn's lens. Most of the pictures were taken with a flash, and when you photograph someone in close-up with a flash, a white dot materializes in the pupils of your subject, mirroring the flash. I cannot help but see this dot as a metonym of Georgia's gaze registering the artist's and bouncing it back at the viewer. A comparison imposes itself with the gaze of Margrét Haraldsdóttir Blöndal in *You Are the Weather*—a work, it seems to me, to which *This is Me, This is You* offers a pendent. A chiasma of sorts links the two works. Whereas "What do you want from me?" is the one constant message which Margrét's gaze seems to be addressing to the camera, in response to what is felt as an intense demand on the part of the artist, no such anxiety is perceptible in the eyes of Georgia. The affectionate and intimate relation between sitter and photographer makes room for the conventional interplay of demand and response congenial to the art of portrait-making that *You Are the Weather* precisely rejects. The photographer begs the subject to supply an expression of what he or she thinks is his or her true self, and the subject complies with an expression which, translated in language, might read as:

"This is me, and I am this and that." So far so good: Georgia supplies the *This is Me* side of *This is Me, This is You*. But what about the *This is You* side? Assuming that "you" refers to the artist, then what is "this"? Where in the work is a self-portrait of the aunt made visible through the portraits of the niece? Where, if not in Georgia's gaze, in its frankness, openness and receptivity, in the confidence it betrays, and in its address to the one it places behind the camera? It is palpable in the pictures that Georgia knows her aunt is an artist. She knows that the versatile images she projects of herself are not destined for the family album but are likely to land some day in a public setting. It is as though she had grasped and foreseen that her aunt Roni, as an artist, was bound to find her identity in the eye of the beholder looking at her work. Wittingly or not, Georgia is addressing a viewer who is looking at Georgia looking at Roni looking at Georgia through her lens. Bedazzling.

I have argued elsewhere that the conceptual content of *You Are the Weather* is the shifting of the "you" from model to spectator. *This is Me, This is You* shifts the "you" from artist to spectator, via the model's gaze, with the result that the triangle is completed when the "you" gets shifted back from spectator to artist. I, Georgia, address you, Roni, and through you, the viewer. You, the viewer, witness Georgia busy drawing a likeness of Roni as a "you," of the artist as addressee. This might explain why the photographs are more landscape than portrait, in spite of their playing with the conventions of portraiture more than any other work Roni Horn has done. For landscape—the Icelandic landscape, especially—has a unique status in Horn's work. It places her in the world and gives her an identity. "Iceland is a verb, and its action is to center." To center, or *to place,* is the verb that addresses the artist with the phrase: "This is you." Landscape is, so to speak, the centering mold from which a self-portrait in the second person is cast. The one piece that Horn thinks of as a self-portrait, in the true sense of a portrait in the first person, is a sculpture that ought to be centered but is not quite. Entitled *Asphere,* it is a solid steel ball whose 13-inch diameter has been expanded in one direction to the point where the distortion becomes barely perceptible. She calls it a homage to androgyny and, more often than not,

59

hints at the idea that androgyny is a sense of identity where the gendered subject—the "I" as adresser—experiences itself as dependent on the point of view from which it is addressed with the ungendered pronoun "you." This is a highly original definition of (her) identity, for it points toward sexual difference not as something that divides humanity into men and women, nor as something that would split the self, but as an ambiguous dialectic of addresser and addressee that slightly distorts the self's sphericity and, by implication, the horizon surrounding it. Whether you are the artist im-mersed in the Icelandic landscape or the gallery-goer surrounded by the artist's work, the horizon is the circle that limits your sight and of which you are the center. With Roni Horn's work, the burden of embodying the center is yours. Or, as she herself says: "I throw the issue of self-identity back out to the viewer."

While circumscribing the viewer with a horizon-like frieze is one of Roni Horn's familiar presentation devices meant to place the viewer at the center of the work, *pairing* identical objects is a device she uses to decenter the viewer, another way of introducing asphericity into the notion of identi-ty. In the photo-installation *Pi* (of which the book version is entitled *Arctic Circles*), both devices come into play. The work is ruled, on the one hand, by the *My-business-is-circumference* adage (a sentence from Dickinson's corre-spondence which the artist took over for *How Dickinson Stayed Home*), and on the other hand, by the *Things-which-happen-again* adage (the generic title for the twin forms placed in different rooms which the artist also calls *Pair Objects*). The gallery presentation of *This is Me, This is You*, however, doesn't follow either adage strictly. It substitutes the frontal, quasi-con-frontational structure of the grid for the frieze, and it insists on the some-times imperceptible, sometimes conspicuous differences that set the paired images a few seconds apart. It has affinities with the way the artist sometimes reproduces *Pair Field*, as a grid of 18 photographs, each being the "portrait" of one of eighteen solid copper or steel objects of equal volume and differ-ent shapes. When installed, the actual work duplicates the eighteen unique forms and scatters the two groups in two different rooms. Experiencing the

work relies strongly on the sense of *déjà-vu* that you get upon entering the second room, thwarted by the fine-tuned differences in the arrangement of the forms on the floor and in the proportions of the rooms. You get the same sense of *déjà-vu* when you come upon the second grid of photos composing *This is Me, This is You* after having seen the first in the other room, until you discover that the paired images are not identical twins. The few seconds that separate them in the photo session render them "aspherical" with respect to one another. Irreversible time is crucial to the experience of both *Pair Field* and *This is Me, This is You*. But the latter work complicates the experience with a touch of fugitiveness having to do with the model in the photos, the mobility of her face, the expressiveness of her features, and the quasi-photosensitive receptivity of her gaze under that of the artist. From the subtle interaction of two irreversibilities arises a dialectic, where difference acts as a measure of change, and change as a measure of identity—a paradox the artist expresses, rather enigmatically, with: "The present is no longer fugitive because my future is in the present tense too."

There is no age in life of which it can be said better that the future is in the present tense than adolescence. But Roni Horn, who is no longer a teenager, speaks of her own future in that sentence. And of her own adult, androgynous identity. Like many other of her works, *This is Me, This is You* is "a mirror for the unseen," and what remains unseen in this piece is herself. Starring Georgia Loy and Georgia Loy only, the work is an ingenuous, loving tribute to the girl's engaging personality, her budding sexuality, and her freedom to become what she decides to become. The aunt has watched her niece go through differences that are a measure of change, and through changes that are a measure of identity, without in any way imposing on her the model of her own identity, and without superimposing her own world view on the images either, whether stylistically or otherwise. She simply gave Georgia the word, to say a hundred times over: *This is Me*. Yet, without *This is You* the work would not truly deserve its title. I have rarely seen a more tactful self-portrait—dedicated, what's more, by Georgia: *to Everyone*.

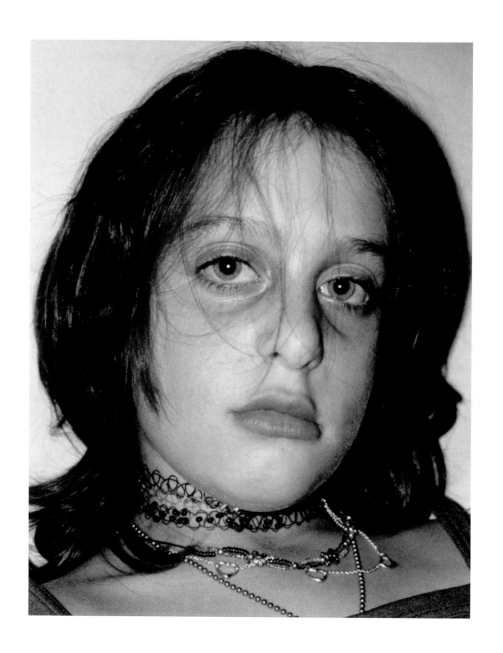

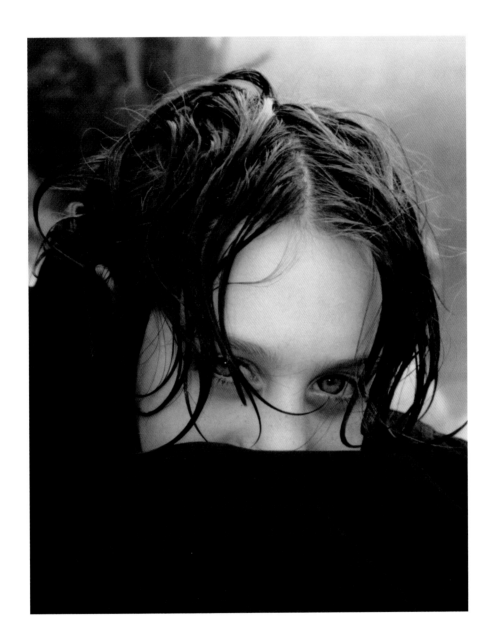

THIERRY DE DUVE

IST KUNSTHISTORIKER UND PHILOSOPH
UND LEBT IN BRÜSSEL

This is Me,
This is You

Affig, altklug, anbetungswürdig, angewidert, anmutig, aufgebrezelt, aufrüh-
rerisch, aus der Dusche steigend, aus der Rolle, Ballon aufblasend, bedau-
ernd, beraubt, bezaubernd, blasiert, böse, Brille tragend, Brötchen kauend,
dich anblickend, dort, drängend, draufgängerisch, drollig, düster, entschie-
den, entschlossen, entsetzt, entspannt, erfinderisch, ernst, erstaunt, erwach-
sen, erwartungsvoll, faul, feminin, fett, feucht, flirtend, fragend, frech,
gegenwärtig, gequält, geringschätzig, geschwätzig, gewöhnlich, glamourös,
glücklich, grimassierend, grinsend, grotesk, heranwachsend, hübsch, hier,
ich-geb-'n-Dreck, im Bild, in der Badewanne liegend, in ihrem Haar fum-
melnd, in ihrer Rolle, intelligent, ironisch, jüdische Mutter, jüdische Prin-
zessin, jungenhaft, juwelengeschmückt, kamerabewußt, kapriziös, Kaugum-
mi kauend, kindisch, klug, kokett, komisch, kopfüber, kurzhaarig, lächerlich,
langhaarig, launisch, liebend, lieblich, listig, mißtrauisch, mit bösem Blick,
mit einem Halm trinkend, mit Kapuze, mit Perücke, mütterlich, nachdenk-
lich, nachgiebig, naiv, natürlich, nie kichernd, nobel, nur selten sich nicht
des Beobachters bewußt, offen, offenherzig, perplex, plump, posierend, reif,
romantisch, Salat essend, Sabra, sauer, schauspielernd, schelmisch, scheu,

schlau, schmollend, schön, schreiend, selbstbewußt, selbstversunken, sexy, sich verstellend, sinnlich, skeptisch, spitzbübisch, spontan, spöttisch, sprühend, starrend, stirnrunzelnd, stolz, stumm, süß, süß-und-sauer, teilnahmslos, tolpatschig, tragisch, traurig, triumphierend, trotzig, unaufrichtig flehend, undankbar, ungläubig, unreif, üppig, Star, süßlich, unmutig, Vamp, verärgert, verlassen, verbindlich, verführerisch, vergeßlich, verkrampft, verliebt, verloren, verspielt, versteckspielend, vertieft, vertrauensvoll, vortäuschend, weiblich, wendig, wütend, widerborstig, zerzaust, zurückgezogen, zweckorientiert.

Die oben aufgeführte Liste von Adjektiven ist ein armseliger Versuch, das sich verändernde Gesicht von Georgia Loy und die Vielfalt ihres Ausdrucks zu beschreiben, während sie in Roni Horns Fotografien – aufgenommen während zweier Jahre, aus denen sich *This is Me, This is You* zusammensetzt –, von Kindheit zu voller Adoleszenz fortschreitet. Georgia Loy ist die Nichte der Künstlerin und sie steuerte den Titel bei. Die Arbeit existiert sowohl für die Wand wie auch in Buchform. Das Buch umfaßt zweimal fünfzig Bildpaare, die Wandinstallation zweimal 48 Bildpaare. Die Bilder jeden Paares wurden innerhalb weniger Sekunden aufgenommen. Ausgestellt in einer Galerie bildet ein Teil der Bilder ein Gitter an der Wand des einen Raumes, während der andere in gleicher Anordnung an der Wand eines anderen Raumes hängt. Die einzelnen Bilder bilden Paare durch die identische Platzierung innerhalb der zwei Gitter. Auf den ersten Blick hat man den Eindruck, das gleiche Werk werde einem zweimal gezeigt. Bemerkt man allerdings die Paare, ertappt man sich dabei, wie man eine bestimmte Fotografie entdeckt und versucht, sie in Erinnerung zu behalten, während man in den anderen Raum rennt, um ihr Gegenstück zu finden, hin und her zwischen den beiden Räumen, wieder und wieder. Die Übung ist zugleich belustigend und frustrierend, als ob die Künstlerin beabsichtigte, daß man den flüchtigen Unterschied zwischen den beiden Schnappschüssen in Körperbewegung umsetzt. Zeit wird Raum. Das Buch besteht eigentlich aus zwei Büchern, Rücken an Rücken geklebt, broschiert und in einen einfachen Schuber gesteckt, die Fotos jeweils auf die rechte Seite jeder Doppel-

seite randabfallend gedruckt, auf geschmeidigem Papier. Die Bilder sind gepaart durch die identische Anordnung in beiden Büchern. Das resultierende Objekt ist ein vertrautes und trotzdem verblüffendes Daumenkino. Man erhält kein Gefühl einer Chronologie, wenn man die Seiten blättert: Das Mädchen wird nicht älter, ihre Befindlichkeit entwickelt sich nicht, ihr Benehmen folgt keinem Muster. Noch gibt es irgendein Gefühl von «vorher und nachher», wenn man unbeholfen die Bildpaare abzugleichen versucht, indem man mit dem Finger einer Hand eine Seite in einem der beiden Bücher markiert. «Narrative zu durchbrechen ist ein wichtiges Mittel, um das Interesse der Leute zu wecken», hat die Künstlerin einmal gesagt. In der Tat. Jedes Foto des Mädchens ist in sich geschlossen, und jedes einzelne ist ein Anfang, wie die ersten Zeilen von Emily Dickinsons Gedichten, die Roni Horn für *Keys and Cues* geborgt hat. Die Fotos sind mehr Landschaft als Porträt. Was die Künstlerin über Island gesagt hat, trifft auch auf das Mädchen zu: «Island wird immer, was es werden wird, und was es werden wird, ist auch keine beschlossene Sache. Hier ist also Island: ein Akt, kein Objekt, ein Verb, nie ein Nomen.» Georgia Loy ist ein Verb. Ein Verb mithilfe von Adjektiven umschreiben zu wollen, ist zum Scheitern verurteilt.

Wieso also nicht nochmals beginnen, anderswo? Das Mädchen ist ein ziemliches Stück. Eine starke Persönlichkeit, kein Zweifel. Und diese Augen! Türkis, bald blau, bald grün, klar wie Wasser, doch rätselhaft undurchsichtig, die meiste Zeit weit offen, vor Intelligenz sprühend und unglaublich empfänglich. Will heißen: weit empfänglicher als ausdrucksvoll, obwohl sie auch ausdrucksvoll sind. Georgia genießt einfach die liebevolle Aufmerksamkeit ihrer Tante. Ihr Blick absorbiert unschuldig und reflektiert wissentlich die Tatsache – nichts als eine bloße Tatsache, die aber durchdrungen ist von Sorge und Liebe –, daß sie betrachtet wird von Roni Horns Linse. Die meisten Bilder wurden mit Blitzlicht aufgenommen, und wenn man jemand in Nahaufnahme mit Blitz fotografiert, wird ein weißer Punkt, der den Blitz spiegelt, in der Pupille des Modells sichtbar. Ich kann nicht anders, als in diesem Punkt eine Metonymie von Georgias Blick zu sehen, der jenen der Künstlerin wahrnimmt und ihn wiederum auf den Betrachter zu-

rückwirft. Ein Vergleich drängt sich auf mit dem Blick von Margrét Haraldsdóttir Blöndal in *You are the Weather* – ein Werk zu dem, wie mir scheint, *This is Me, This is You* ein Gegenstück bietet. Dieser Chiasmus, wie man sagen könnte, verbindet die zwei Arbeiten. Während «Was willst du von mir?» die eine ständige Frage ist, die Margréts Blick an die Kamera stellt, in Erwiderung auf die gefühlte intensive Erwartung der Fotografin, ist keine solche Beklemmung wahrnehmbar in Georgias Augen. Die zuneigungsvolle und intime Beziehung zwischen Modell und Fotografin lässt Raum für das konventionelle Spiel von Forderung und Erwiderung, das der Porträtkunst entspricht, die *You are the Weather* eben gerade verwirft. Die Fotografin bittet das Modell um einen Ausdruck dessen, von dem er oder sie denkt, daß es sein/ihr wahres Ich ist, und das Modell entspricht dem mit einem Ausdruck, der, übersetzt in Sprache, so lauten könnte: «Dies bin ich, und ich bin dies und das.» So weit, so gut: Georgia vertritt die *This is me*-Seite von *This is Me, This is You*. Aber was ist mit der *This is You*-Seite? Angenommen, daß dieses «you» sich auf die Künstlerin bezieht, was wäre dann das «this»? Wo in dieser Arbeit findet sich ein Selbstporträt der Tante, das sichtbar wird in den Porträts der Nichte? Wo, wenn nicht in Georgias Blick, in seiner Ehrlichkeit, Offenheit und Empfänglichkeit, im Vertrauen, das er verrät, und in seinem Bezug zur Person, die er (der Blick) hinter der Kamera weiß? In diesen Bildern ist spürbar, daß Georgia weiß, daß ihre Tante eine Künstlerin ist. Sie weiß, daß die wandelbaren Bilder, die sie projiziert, nicht für das Familienalbum bestimmt sind, sondern höchstwahrscheinlich eines Tages in einem öffentlichen Raum landen werden. Es scheint, als ob sie begriffen und vorhergesehen hätte, daß ihre Tante Roni als Künstlerin ihre Identität in den Augen des Betrachters ihres Werks finden mußte. Wissentlich oder nicht richtet sich Georgia an den Betrachter, der Georgia sieht, die Roni sieht, die Georgia durch ihre Linse betrachtet. Verwirrend.

Anderswo habe ich ausgeführt, daß der konzeptuelle Inhalt von *You are the Weather* die Verschiebung des «Du» vom Modell zum Betrachter ist. *This is Me, This is You* verschiebt das «Du» vom Künstler zum Betrachter über den Blick des Modells, mit dem Ergebnis, daß das Dreieck vollständig

ist, wenn das «Du» vom Betrachter zur Künstlerin zurückverschoben wird. Ich, Georgia, wende mich an dich, Roni, und durch dich an den Betrachter. Du, der Betrachter, siehst, wie Georgia dabei ist, ein Abbild von Roni als «Du» zu zeichnen, der Künstlerin als Adressatin. Das erklärt vielleicht, weshalb die Fotografien eher Landschaften als Porträts sind, obwohl sie mehr als alle anderen Werke Roni Horns mit den Konventionen des Porträtierens spielen. Denn Landschaft – insbesondere die isländische Landschaft – hat einen besonderen Stellenwert in Horns Werk. Landschaft verortet sie in der Welt und gibt ihr eine Identität. «Island ist ein Verb, und die Handlung ist das Einmitten.» Einmitten oder verorten ist das Verb, das die Künstlerin mit dem Satz «This is You» anspricht. Landschaft ist sozusagen die zentrierende Form, in die ein Selbstporträt in der zweiten Person gegossen wird. Die Arbeit, die Roni Horn als Selbstporträt betrachtet – im eigentlichen Sinne eines Porträts in der ersten Person –, ist eine Skulptur, die zentriert sein sollte, aber es nicht ganz ist. Die Arbeit mit Titel *Asphere* ist ein Ball aus gehärtetem Stahl, dessen 30 cm Durchmesser in eine Richtung bis an den Punkt gedehnt wurde, wo die Verzerrung gerade wahrnehmbar wird. Sie nennt es eine Hommage an die Androgynie und deutet hin und wieder die Idee an, daß Androgynie ein Verständnis von Identität ist, in dem das geschlechtsdefinierte Subjekt – das «Ich» als Sprecher – sich selbst als abhängig erfährt vom Blickpunkt, von dem aus es mit dem geschlechtsneutralen Pronomen «Du» angesprochen wird. Dies ist eine außerordentlich findige Definition von (ihrer) Identität, denn sie zeigt sexuelle Differenz nicht als eine Tatsache, welche die Menschheit in Männer und Frauen teilt, noch als etwas, das das Selbst teilen würde, sondern als eine mehrdeutige Dialektik von Sprecher und Angesprochenem/-er, welche die Sphärenhaftigkeit des Selbst leicht verzerrt und folglich implizit den sie umgebenden Horizont. Sei's die Künstlerin in einer isländischen Landschaft oder der Galeriebesucher, umgeben von ihrem Werk, der Horizont ist jener Kreis, der unsere Sicht beschränkt, und dessen Mittelpunkt wir sind. In Roni Horns Werk fällt uns die Bürde, den Mittelpunkt zu verkörpern, zu. Oder wie sie sagt: «Ich werfe die Frage der Selbstidentität auf den Betrachter zurück.»

Eine von Roni Horns bekannten Präsentationsarten, um den Betrachter in den Mittelpunkt des Werkes zu setzen, ist das Umgrenzen des Betrachters mit einem horizontähnlichen Fries, das Paaren von identischen Objekten ist hingegen ein Mittel, um den Betrachter zu dezentrieren, eine andere Weise, Nicht-Sphärenhaftigkeit in den Begriff der Identität einzuführen. In der Fotoinstallation *Pi* (deren Buchversion *Arctic Circles* betitelt ist) kommen beide Methoden ins Spiel. Die Arbeit wird zum einen beherrscht durch das Motto *My business is circumference* (Meine Arbeit ist das Umgrenzen, ein Satz aus den Dickinson-Briefwechseln, den die Künstlerin für *How Dickinson Stayed Home* übernahm), und zum anderen durch das Motto *Things which happen again* (Dinge, die wieder geschehen), der Gattungstitel für die Zwillingsformen, die in verschiedenen Räumen gezeigt werden, welche die Künstlerin auch *Pair Objects* (Objektpaare) nennt. Die Galeriepräsentation von *This is Me, This is You* folgt keinem der beiden Mottos in strikter Weise. Es ersetzt den Fries durch die frontale, quasi-konfrontierende Struktur des Gitters und beharrt auf den manchmal unwahrnehmbaren, manchmal auffälligen Unterschieden, welche die beiden Bilder einige Sekunden auseinander setzen. Es zeigt sich hier eine Verwandtschaft mit der Weise, in der die Künstlerin manchmal *Pair Field* als ein Gitter von 18 Fotografien reproduziert, jede ein «Porträt» von einem der 18 Kupfer- oder Stahlobjekten mit gleichem Volumen, aber unterschiedlicher Form. Installiert verdoppelt die Arbeit die 18 je einmaligen Formen und verteilt die zwei Gruppen auf zwei verschiedene Räume. Die Erfahrung der Arbeit beruht stark auf einem Gefühl des *déjà-vu,* das man beim Betreten des zweiten Raumes verspürt, das allerdings hintertrieben wird durch die fein abgestimmten Unterschiede in der Anordnung der Formen auf dem Boden und durch die Maße der Räume. Man hat das gleiche Gefühl von *déjà-vu*, wenn man auf das zweite Gitter von Fotografien, aus denen sich *This is Me, This is You* zusammensetzt, trifft, nachdem man das erste Gitter im anderen Raum gesehen hat, bis man entdeckt, daß die gepaarten Bilder nicht-identische Zwillinge sind. Die wenigen Sekunden, die sie trennen, machen sie «a-sphärisch» in ihrem Bezug zueinander. Die Unumkehrbarkeit der Zeit ist

entscheidend für die Erfahrung von *Pair Field* und *This is Me, This is You*. Aber letzteres Werk macht diese Erfahrung komplizierter durch einen Hauch von Flüchtigkeit, der vom Modell rührt, der Ausdruckskraft ihres Gesichts und der gewissermaßen photosensitiven Empfänglichkeit ihres Blickes unter jenem der Künstlerin. Aus der subtilen Interaktion der beiden Unumkehrbarkeiten entsteht eine Dialektik, in der Differenz zum Maß der Veränderung wird und Veränderung zum Maß der Identität – ein Paradox, das die Künstlerin ziemlich rätselhaft so ausdrückt: «Die Gegenwart ist nicht mehr flüchtig, weil meine Zukunft auch in der Gegenwart (als Zeit-form, A. d. Ü) ist.»

Es gibt keine Zeit im Leben, von der man eher sagen könnte, daß die Zukunft in der Gegenwart ist, als die Adoleszenz. Aber Roni Horn, die kein Teenager mehr ist, spricht in diesem Satz von ihrer eigenen Zukunft. Und von ihrer erwachsenen, androgynen Identität. Wie viele andere ihrer Werke ist *This is Me, This is You* ein «Spiegel des Ungesehenen», und was ungese-hen bleibt in diesem Werk, ist sie selbst. Georgia Loy ist der Star und nur Georgia Loy. Die Arbeit ist ein erfindungsreicher, liebender Tribut an die einnehmende Persönlichkeit des Mädchens, ihre erwachende Sexualität und ihre Freiheit zu werden, wen zu werden sie sich entscheidet. Die Tante beobachtet, wie ihre Nichte Differenzen durchlebt, die ein Maß der Verän-derung sind, und Veränderungen, die ein Maß der Identität sind, ohne ihr in irgendeiner Weise das Modell ihrer eigenen Identität aufzuzwingen und ohne ihre eigene Weltsicht auf die Bilder zu projizieren, stilistisch oder in irgendeiner anderen Weise. Sie gab ganz einfach Georgia das Wort, um hundert Mal zu sagen: *This is Me* (Das bin ich). Aber ohne *This is You* (Das bist du) würde die Arbeit ihren Titel nicht wirklich verdienen. Ich habe selten ein taktvolleres Selbstporträt gesehen – zudem widmete es Georgia: *to Everyone* (für alle).

Pi

Pi, 1994–1997, is an installation of 45 Iris-printed photographs: 20.25 x 20.25, 20.25 x 16.25, 20.25 x 27.25", hung above eye level in a surround forming a horizon on the four walls of a room.

The book *Arctic Circles*, a closely related work, was published in 1998. It is the 7th volume of the work *To Place*, begun in 1989.

Pi, 1994–1997, ist eine Installation von 45 Iris-Prints (50.5 x 50.5, 50.5 x 41.3, 50.5 x 69cm), auf Augenhöhe und in durchgehender Folge entlang der vier Wände eines Raumes gehängt.

Das Buch *Arctic Circles*, ein eng verwandtes Werk, wurde 1998 veröffentlicht. Es ist der 7. Band der Arbeit *To Place*, begonnen 1989.

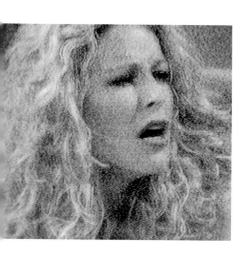 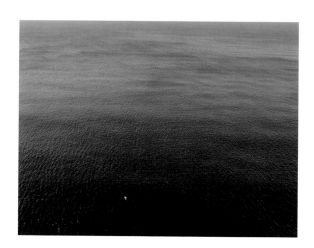

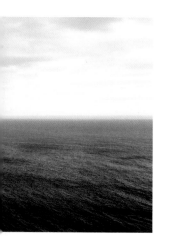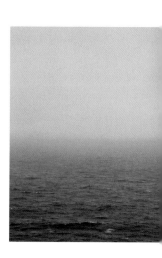

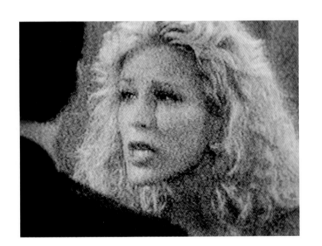

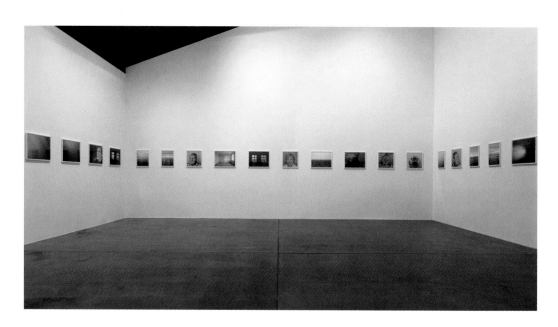

PATRICK PAINTER GALLERY, LOS ANGELES, 1998

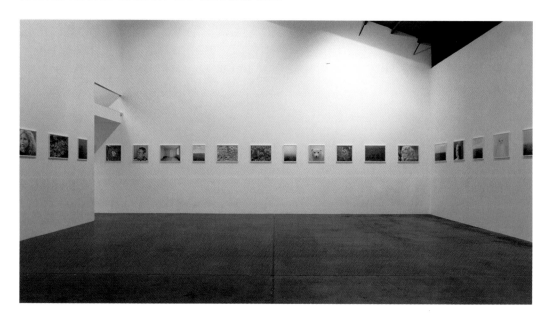

80

U RS S TAHEL

IS CURATOR AND DIRECTOR OF
THE FOTOMUSEUM WINTERTHUR

Serenely sailing like sea-gulls in the wind

Looking at these forty-five Iris prints, we have the impression of an airy succession of images extending or even stretching themselves along the walls, enveloping us. Loose links of the same height that our perception easily ties together, their rhythmic arrangement locking them into a continuity with neither start nor finish. They are placed a little above eye level, so that, seen from a few meters' distance, they create the impression that we are immersed in a room circumscribed by a series of images like a horizon line. The eye breezily jumps from one representation of the horizon to the next, some of them loosely repeated, reappearing alone or doubled as pairs.

Beginning and end of the sequence are not predetermined, in fact, they don't exist. As a result, we viewers come into play from the first second as jointly responsible for the work. We choose our entrance into this endless succession of images for ourselves, then follow our own paths, backward or forward, clockwise or counterclockwise. We might "enter," for example, with the many images of the sea that from afar seem like graphic diagrams, divided into sea and sky. The different color saturation of these two realms draws our gaze to the center of the image, into its depth, to the horizon, but it doesn't lead us into its expanse, for these photographs of horizons are upright in format, like portraits. Their width seems truncated. Only repetition and addition create a sense of the sea's and the horizon's vastness.

Our gaze then turns right to look into the face, the eyes, of Björn, an older man who stares through one or two windows, mirrored in his eyes, onto the expanse of the sea; at the same time, he seems to listen inward, as if in a state of suspension. Next our gaze encounters an austere room flooded with light. It is almost empty yet it does not appear uninhabited: everything is well-worn—the walls, the ceiling, the dull, much-scrubbed wooden floor. Had our gaze traveled to the left, however, our perception would not have been shaped by spatial transformation but by the passing of time. In this direction a second image of the horizon follows the first one, but time has passed (or, since we are moving counterclockwise, it may have been turned back). The light in the second image is more muted; the colors are turning gray; darkness is creeping up in the image's foreground. The third photograph offers a view from a room, through two windows with crossbars, onto the glistening sea. The room appears dark in the back light, almost a camera obscura, if a camera obscura had two eyes. This image is followed by a video still from an American soap opera, a photograph of a luminous TV screen.

The calm archetype of a landscape image—water, air, horizon—as point of access demands searching, investigating, contemplative viewers. But the series of images contains a number of other possible entrances, for instance the serene, timeworn face of Hildur, Björn's wife. Her soft, slightly questioning eyes lead to the piercing eyes of an owl; then, in a jump, to a dark-eyed arctic fox; on to a seal's anthropomorphically appealing "faithful" eyes; and finally to Cassie in the soap opera, her eyes feigning sadness. This point of access would result in a more active, dialogic relationship between images and viewer. Hopping from one pair of eyes to the next would correspond to a perception that is drawn to the strongest stimuli, following the second central point of reference (besides landscape): human beings, the other.

This idea may sound daring in relation to the austere, precisely conceived works of Roni Horn, but in *Pi* this seems intended. Everyone can circle around this work, like sea-gulls circling over the ocean. And if we circle long and attentively enough, we will encounter other viewers' circles (of meaning), the intersections of the fields of meaning hidden in the work. Rather than rigidly guiding the viewer's gaze, the work interrupts any suggestion of a nar-

rative flow after three or four images, only to resurface after four or five images on the next wall. There are formal analogies among photographs: Cassie's shaggy, open blond hair, for instance, leads the eye to an eider duck nest or to a field of eider down; eyes lead to other eyes; horizon to horizon. But these similarities of appearance only cause a slight stir, and then, once again, a light, equanimous breeze carries us further down the series of images, in their linear arrangement of three different formats—horizontal and vertical, oblong and square. This arrangement guides us from image to image in a quiet, agile manner, without clusters, without screaming, almost like baroque music.

The work in its most basic form was created in Melrakkasletta, in the northernmost part of Iceland, where the Arctic Circle—the map line that separates the Arctic north, with its darkness in winter and its permanent daylight in summer, from more temperate climates—touches the northern tip of the island like a tangent. This is a hard, exposed area whose few inhabitants must live in accord with nature. The eider duck, for example, plucks its own softest down feathers to build a nest with them. Humans wait until the eggs are hatched to then collect the eider down—a dual use that testifies to an understanding and respect for nature's cycles. This process plays an important role in *Pi*; in fact signs of it—a frontal view of the nest's feathers, the eggs in the nest, a view of the piled-up eider down, leftover feathers swaying across the otherwise empty wooden floor—keep reappearing throughout the work. A mimesis that almost weaves itself into natural processes, it is married to nature's conditions.

The longer we look, the more such traces we can discover. The denser the work, the more interwoven it seems, despite its composed appearance. All of these signs, loosely ordered by perception, condense themselves in a complex field of meaning, a net in which every component codetermines the others. The photograph of the fading wallpaper with its netlike pattern might be read as a metaphor for this. Just as hardly an image could be removed from the sequence, the images as whole seem to "talk" about this net and this interconnecting equilibrium, about a perpetual, recurring process. Different times visualize themselves in the images—swiftly passing time in the alternation of day and night and the tides, slowly passing time in birth and aging, in blossom and decay, time so slow that it is almost imperceptible in the changes of geol-

ogy. Spaces and places of different dimensions visualize themselves: the nest, the room, the rocks, the sea, the sky. There is an encounter of abstract and real geographies. Micro-, macro-, and mediacosm are interwoven: eider down becomes the star-studded sky; wild blond hair seen on TV is transformed in landscape, in a precipitating rock, dotted with the sea-gulls' white droppings; a light breeze transforms the sea into white noise on a TV screen. There are parallel characters to Björn and Hildur in the soap opera. All of these are signs of a continuous, eternal process and of mutual implication.

The naming or definition of these signs causes a slight disruption as the ease, the diversity, the calm, subdued tone of the work gets lost and the images become unintentionally sharpened, even charged. The carefully balanced equilibrium is in jeopardy; the work functions like DNA, its components being functional and having no meaning beyond their function. As a whole, though, they generate genetic hereditary information and encircle life in a spiral. The number π, an abstract mathematical quantity determining the ratio of the circumference to the diameter of a circle, becomes intelligible in *Pi*, and its circular forms and cyclical processes appear in the circular shape of the nest, in the eyes, in the circling of the birds, the return of the tides, the days, the waves, the rhythm of birth and death. In a way that unifies place, time, and identity, *Pi* suggests the constant factors of life, the passing of time, the return and the connection of the different elements, our way of inscribing ourselves into nature. They grow together in a process of realities. There is a sublime aspect to *Pi,* its net of images suggesting an element that defies representation. And yet, in *Pi* the sublime is shown without theatrical horrors, without drama. On the contrary, it is dry and rigorous. To lighten the burden of meaning and to situate the work in the present, the sublime even appears to be flippantly linked to the kitsch of *Guiding Light*, a soap opera that is regularly broadcast in Iceland. The title assumes an ironic meaning in the context of this work which comprises a lighthouse.

The sublime shows itself in Horn's work through the precariousness and the determination of existence set off by every single being, by every process. The doubled doubling of the representation of biological scarcity and abundance by aesthetic simplicity and self-containment are the key to this work.

URS STAHEL

IST KURATOR UND DIREKTOR DES
FOTOMUSEUMS WINTERTHUR

Gleichmütiges Segeln, wie die Möwen im Wind

Beim Anblick der 45 Iris-Prints entsteht der Eindruck, einer luftigen Bilderkette zu begegnen, die sich gestreckt, fast gedehnt den Wänden entlang zieht und sich so um die Betrachter herum legt. Lose Glieder gleicher Höhe, die unsere Wahrnehmung wegen der rhythmischen Anordnung leicht miteinander verknüpft und zu einem Band ohne Anfang und Ende schließt. Etwas über Kopfhöhe sind sie angeordnet. Aus einigen Metern Distanz vermitteln sie so das Gefühl, als tauchten wir, die Betrachter, in einen Raum ein, den diese Bilderkette wie eine Horizontlinie begrenzt. Das Auge hüpft leicht, wenn es den Darstellungen der Horizonte folgt, die lose wiederkehrend, manchmal einzeln, manchmal als Paar in der Reihe auftauchen.

Anfang und Ende des Werkes sind nicht vorgegeben, existieren nicht. Dadurch ist der Betrachter von der ersten Sekunde an mit im Spiel, mitverantwortlich. Er selbst wählt seinen Einstieg in das endlose Bilderband und geht seinen Weg, vor- oder rückwärts, im Uhrzeigersinn oder entgegen drehend. Zum Beispiel kann er über die zahlreichen Meeresbilder «eintreten», die mit ihrer Zweiteilung in Himmel und Wasser von weit gesehen wie grafische Tafeln wirken. Die unterschiedlichen Farbsättigungen von Himmel und

Meer ziehen den Blick in die Mitte des Bildes, in die Tiefe, zum Horizont – hingegen nicht so sehr in die Weite, denn diese Fotografien von Horizonten sind hoch-, sind porträtformatig, wirken in der Weite beschnitten. Weite stellt sich erst durch die Wiederholung und Addition der Horizonte ein. Der Blick des Betrachters dreht sich anschließend, seiner Sehgewohnheit folgend, nach rechts, direkt ins Gesicht, in die Augen von Björn, einem älteren Mann, der durch ein, zwei Fenster hindurch, die sich in seinen Augen spiegeln, hinaus in die Weite des Meeres schaut und gleichzeitig nach innen zu horchen scheint. Und so in einem Schwebezustand verharrt. Dann fällt der Blick in einen kargen, aber von Licht durchfluteten Raum. Er ist fast leer und wirkt gleichwohl nicht unbelebt. Gebrauchsspuren finden sich überall, an Wänden, Decken und auf den mattgescheuerten Holzriemen am Boden, und sie lassen den Raum beredt erscheinen. Aus der geographischen Weite des Meeres wandert der Blick zum Gedankenraum eines Mannes und dann in einen Arbeitsraum, den Innenraum eines Holzhauses – eine lose Korrespondenz entsteht.

Wäre der Blick des Betrachters hingegen zuerst nach links gewandert, so hätte weniger das Gefühl von räumlicher Transformierung die Wahrnehmung geprägt als das Vergehen von Zeit. Ein zweites Horizontbild folgt da auf das zuerst wahrgenommene. Erneut sind Himmel und Meer fast symmetrisch zweigeteilt, doch es ist eben Zeit vergangen (oder – durch das Schauen gegen den Uhrzeiger-Sinn – allenfalls zurückgedreht worden). Das Licht auf dem zweiten Bild ist stumpfer, die Farben grauen ein, im Vordergrund des Bildes schleicht Dunkelheit hoch. Die dritte Fotografie bietet einen Blick aus einem Zimmer durch zwei Kreuzfenster an, hinaus aufs helle Meer. Der Raum wird im Gegenlicht fast schwarz und wirkt dadurch wie eine (zweiäugige) Camera Obscura. Diesem Bild folgt ein Videostill aus einer amerikanischen Soap Opera, also die Fotografie eines selbstleuchtenden Bildschirms nach.

Der Einstieg über diesen ruhigen Archetypus eines Landschaftsbildes – Wasser, Luft, Horizont – verlangt suchende, forschende, kontemplative Betrachter. Doch die Folge von Bildern bietet viele Einstiege an: zum Beispiel über das in sich ruhende, von der Zeit geprägte Gesicht von Hildur, der Frau von Björn, von ihren sanften, leicht fragenden Augen zu den stechenden

Augen der Eule und dann, springend, zu den dunklen Augen des arktischen Fuchses, hin zu den anthropomorph wirkenden, «treuen» Augen des Seehundes und schließlich zu den Traurigkeit vorspielenden Augen von Cassie aus der Soap Opera. Dieser Einstieg ergäbe einen auffallend aktiveren, dialogischen Bezug zwischen den Bildern und den Betrachtern. Das Hüpfen von Augenpaar zu Augenpaar entspräche einer Wahrnehmung, die den stärksten Reizen verfällt oder der zweiten zentralen Orientierung, jener am Menschen gegenüber (neben jener an der Landschaft), folgt. Dieser Gedanke klingt ein wenig gewagt angesichts der streng und genau konzipierten Werke von Roni Horn, doch in *Pi* wirkt dies so angelegt. Jeder kann darin seine Kreise ziehen, fast so, wie die Möwen ihre Kreise über dem Meer ziehen, und zieht er sie lange und aufmerksam genug, stößt er irgendwann auf die (Bedeutungs-) Kreise anderer Betrachter und auf die Verknüpfungen der im Werk verborgenen Bedeutungsfelder. Die Sicht aufs Werk wird nicht streng geführt, vielmehr werden Anklänge eines narrativen Flusses beim zweiten, dritten Bild gekappt, unterbrochen und tauchen erst viel später, an anderer Stelle oder an der nächsten Wand wieder auf. Im Werk sind Andeutungen von formalen Analogien aufzufinden: das struppige, offene blonde Haar von Cassie zum Beispiel läßt das Auge hinüber zum Nest der Eiderenten oder zum Daunenfeld wandern, Augen führen zu Augen, Horizonte zu Horizonte, doch die gestalthafte Ähnlichkeit läßt einzig einen leichten Wirbel aufkommen, dann weht uns wieder ein leichter, gleichmütiger Wind durch die Bilder, durch die lineare Rhythmisierung von drei verschiedenen Formaten – horizontales und vertikales Rechteck sowie das Quadrat –, die leise, bewegt, jedoch ohne Cluster, ohne Aufschrei, eher wie Barockmusik durch die Bilder führt. Ein Thema erscheint, wird abgelöst, taucht später wieder auf, Stränge, die sich bemerkbar machen und wieder verschwinden. Der Blick der Betrachter tanzt entlang der Bilder um eine imaginäre Mittellinie herum.

In seiner rohen Form entstand das Werk in der Gegend von Melrakkasletta, im nördlichsten Teil von Island. Dort, wo der Polarkreis – der auf der Karte den arktischen Norden mit seiner winterlichen Totaldunkelheit und seiner sommerlichen Immerhelligkeit von den gemäßigteren Zonen trennt –, sich wie eine imaginäre Tangente an die Nordspitze Islands legt. Eine einsa-

me, harte, exponierte Gegend, wo die wenigen Menschen gezwungen sind, mit der Natur im Einklang zu leben. Zum Beispiel in dieser Weise: Die Eiderente zupft sich jeweils die eigenen feinsten Bauchfedern, um damit ein Nest zu bauen. Die Menschen warten, bis die Eier ausgebrütet sind und sammeln anschließend diese Daunen für ihren Gebrauch ein. Eine Doppelnutzung, die von Einsicht, von Respekt für die Naturabläufe zeugt. In *Pi* spielt dieser Vorgang eine wichtige Rolle, Zeichen von ihm – die direkte Aufsicht auf die Federn des Nestes, auf die Eier im Nest, dann der Blick auf angehäufte Daunen und auf Reste von Federn, die über den sonst leeren Holzboden wehen –, ziehen sich durch die Arbeit. Eine Anverwandlung, die sich fast schon in die Naturvorgänge einwebt, sich mit ihren Vorgaben vermählt. Entsprechend wirken die Bilder von präparierten, ausgestopften Tieren wie Porträts von Darstellern in diesem Stück.

Je länger man hinschaut, desto mehr solcher Spuren lassen sich entdecken, desto dichter, verwobener erscheint das Werk, trotz seiner gelassenen Erscheinung. All die Zeichen, durch die Wahrnehmung ein wenig sortiert, verdichten sich zu einem komplexen Bedeutungsfeld, zu einem Netz, in dem jedes Teil die anderen mitbestimmt. Die Fotografie der verblassenden Wandtapete mit ihrem netzartigen Muster läßt sich als Sinnbild dafür verstehen. So wie kaum ein Bild aus der Reihe genommen werden könnte, ohne das Gleichgewicht zu stören, so scheinen die Bilder insgesamt von diesem Netz und diesem verbindenden, verknüpfenden Gleichgewicht, vom Kommen und Gehen, Geben und Nehmen, von einem ständigen, wiederkehrenden Prozeß zu «reden». In ihnen visualisieren sich unterschiedliche Zeiten – schnelle Zeit im Tag- und Nacht- und im Gezeitenwechsel, langsamere Zeit im Geborenwerden und Älterwerden, im Erblühen und Vergehen, langsame, gedehnte Zeit in den Veränderungen der Geologie. Und es visualisieren sich Räume, Orte unterschiedlicher Dimensionen: das Nest, das Zimmer, der Felsen, das Meer, der Himmel. Es begegnen sich abstrakte und reale Geographie, es vernetzen sich Mikro-, Makro- und Medienkosmos: Daunen werden zum Sternenhimmel, wilde blonde Medienhaare zur Landschaft, auch zum steilen, von weißem Kot übersäten Landefelsen der Möwen, eine leichte Brise verwandelt das Meer zum rauschenden Bildschirm. Hildur und Björn

haben ihre Parallelfiguren in der Soap Opera. Eier können als Saat und Daunen als Ernte gelesen werden. Alles Zeichen eines ständigen, ewigen Prozesses und sich gegenseitig Bedingens.

Das Aussprechen, Benennen dieser Zeichen stört ein wenig, weil dadurch die Leichtigkeit, die Auffächerung, die gelassene, zurückhaltende Tonalität im Werk verloren gehen und dabei die Bilder ungewollt geschärft, ja geladen werden. Das austarierte Gleichgewicht der Arbeit droht zu wanken. Die Arbeit funktioniert ähnlich wie eine DNS: die einzelnen Bausteine – Aminosäuren, Enzyme, Wasserstoffbrücken – sind funktional, tragen keine andere Bedeutung als ihre Funktion, zusammen hingegen generieren sie die genetische Erbformation, umkreisen sie spiralförmig, was dann Leben bedeutet. Die Zahl π, mathematisch eine abstrakte Größe, eine Konstante im Verhältnis von Radius zu Kreisumfang, konkretisiert sich in *Pi* in zirkulären Formen und zyklischen Abläufen: das kreisrunde Nest, die Augen, das Kreisen der Vögel, das Wiederkehren der Gezeiten, der Tage, der Wellen, der Rhythmus von Geburt und Tod. *Pi* läßt Konstanten des Lebens anklingen, das Vergehen von Zeit, das Wiederkehren, das Vernetzen der verschiedenen Elemente, das sich Einschreiben in die Natur, in einer Art und Weise, daß Ort und Zeit und Identität eins werden, ineinander verwachsen – in einem Prozeß der Wirklichkeiten. *Pi* birgt ein Erhabenes, ein Nichtdarstellbares in seinem Bildernetz, jedoch ein Erhabenes ohne theatralischen Schrecken, ohne Drama, das vielmehr fast trocken, karg daherkommt. Das sogar, wohl um von der Schwere der Bedeutung zu entlasten und das Werk in der Gegenwart, nicht in der Ewigkeit zu situieren, sich augenzwinkernd mit dem Kitsch der Soap Opera vernetzt, die regelmäßig auf Island ausgestrahlt wird und den Titel *Guiding Light* trägt. Ein Titel, dem im Kontext des Werkes – mit einem Leuchtturm als ein Teil davon – unwiderruflich ironische Bedeutung zuwächst.

Das Erhabene zeigt sich bei Roni Horn im Prekären und in der Bedingtheit und Bestimmtheit der Existenz, akzentuiert von jedem einzelnen Lebewesen und Vorgang. Die doppelte Doppelung der Darstellung von biologischer Kargheit und Erfülltheit mit Mitteln ästhetischer Einfachheit und Geschlossenheit wird zum Schlüssel dieses Werkes.

Clowd and Cloun (Blue)

Clowd and Cloun (Blue), 2001, is an installation of 32 C-printed pho-
tographs, 27 x 27 and 27 x 35". Sixteen head shots of a clown performing
are sequenced with sixteen photographs of a cloud drifting. They are in-
stalled as a surround on the four walls of a room.

A complementary work, *Clowd and Cloun (Gray)*, produced at the
same time, has a similar structure.

Clowd and Cloun (Blue), 2001, ist eine Installation von 32 C-Prints,
68.5 x 68.5 cm und 68.5 x 89 cm. Sechzehn Aufnahmen eines auftreten-
den Clowns werden in einer Sequenz mit sechzehn Aufnahmen einer
schwebenden Wolke gezeigt. Sie sind in durchgehender Folge an den vier
Wänden eines Raumes installiert.

Ein ergänzendes Werk, *Clowd and Cloun (Gray)*, zur gleichen Zeit
entstanden, hat eine ähnliche Struktur.

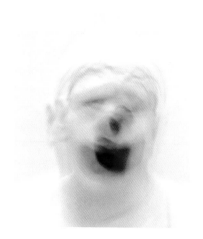

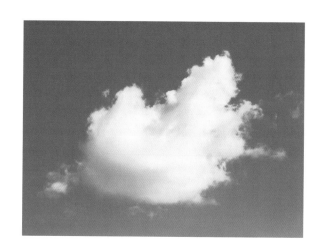

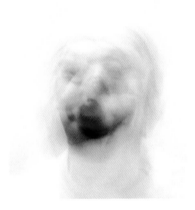
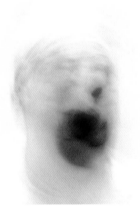

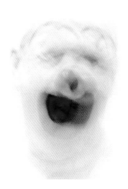

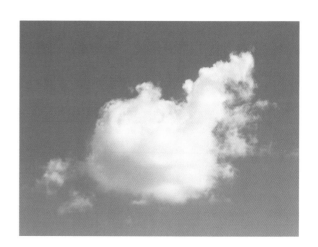

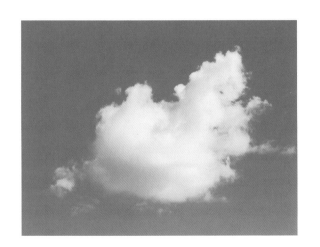

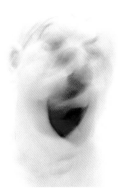

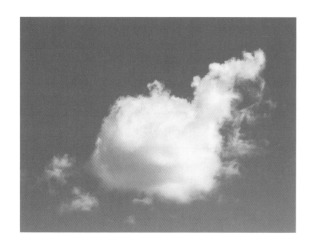

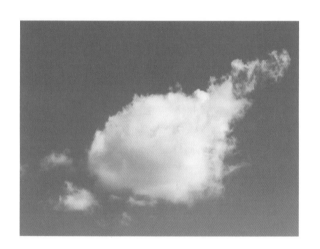

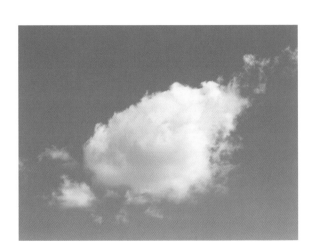

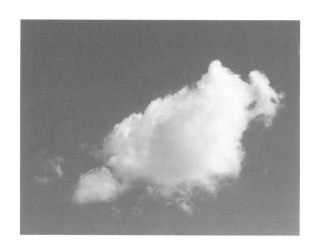

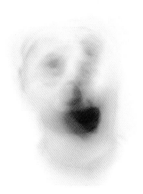

PAULO HERKENHOFF

ARTISTIC DIRECTOR OF THE XXIV BIENAL DE
SÃO PAULO (1998), LIVING IN RIO DE JANEIRO

The Elusive Treasure of Roni Horn

In his "Paradoxe sur le comédien" (1781), Diderot argued that an actor needs insensibility and emotional distance to perform a role. Diderot's title points to semantic issues in the visual system that Roni Horn uses in *Clowd and Cloun (Blue):* paradox, (in)sensibility, and the comedian (the performative element, be it water or a clown). The work is an installation in which sixteen photographs of a clown and sixteen photographs of a cloud alternate on the four walls of a room. Each image of the clown denotes the exaggerated movements of the figure; only all of the cloud images together indicate the movement of the cloud. The stream of these two groups of intercalated photographs evolves around the room. There is no prescribed itinerary, and Horn rejects static and symmetrical binaries by every means available, from gender to topology.[1] One finds no explicit idea to account for the juxtaposition of photographs of a cloud and photographs of a clown, except for the paradoxes, oxymorons, aporias, and witchcraft in Horn's poetical procedures.

QUARTET The photographs in *Clowd and Cloun (Blue)* make the figure of the clown into something diffuse and the evanescent matter of the cloud into a cohesive mass. The clown is change. He is a form, something lacking emotional content, whether it be laughter or melancholy. Is he acting, *à la Diderot?* Each image of him is different from the one before, a discontinuous fragment of time that gets its autonomy from his formulation of one of his transient physiognomies or facial expressions. Meanwhile the slow, ephemeral cloud passes through the entire group of images as a continuity, and in a circular itinerary. Horn is not a determinist, and *Clowd and Cloun (Blue)* activates mutability without causation. Recurrence and circularity subsume the images, making them equal. The hermeneutic challenge of *Clowd and Cloun (Blue)* articulates a visual quartet: the cloud and the clown, the artist and the viewer.

1 : LIQUIDITY Horn's work collides with the position of Jean-François Lyotard on the acts of reading and looking: *"Recuser la visibilité du lisible,"* challenging the visibility of the readable, and *"Lire est entendre et non pas voir,"* to read is to hear, not to see.[2] In the confrontation of image and writing *(écriture)* that establishes the visibility of the readable, language becomes a point of tension. *Clowd and Cloun (Blue)* retains the linguistic rhythm of *Still Water (The River Thames, for Example)* (1999) and evokes the implicit textuality and the book form of Horn's *Dictionary of Water* (2001), a pure, wordless flux of rectangular images of water. Horn unfolds the personas of water: "Water is always an intimate experience," she concludes, "even as rain or ocean or river." Clouds—water in dispersed state—fit into Horn's discourse on liquid reality: "Watching the water, I am stricken with vertigo of meaning."

The paradoxical topology of *Still Water (The River Thames, for Example)* maps water at the root of access to language. Images of water receive tiny numbers that correspond to marginal hermeneutic footnotes, much as in the argumentative method of the philosopher Ludwig Wittgenstein. Horn's paradox in *Still Water* … is that of mapping the unmappable, in *Clowd and Cloun (Blue)* that of capturing the transformations of a cloud,

something constantly in metamorphosis. She approaches (via Jacques Derrida) the Baudelairean issue of making the impossible possible. Horn embraces the theory that the impossibility of language is also the birth of language.[3] The linguistic texture of her work must be as dense as the surface of any "photographic" water. "Water murmurs"[4]: would this be a merely physical sound, or the utterance of language?

2 : C A N W A T E R B E A R R E S T E D ?
"As is often said of photography, this photograph is a frozen moment." Horn detects an oxymoron here, since "a frozen moment is not a moment at all." Water interests her as a linguistic body that cannot be arrested. Horn's photographic gaze comprises shooting, choosing, and articulating images as a semiological strategy. It isolates and decontextualizes them as a way of problematizing signification. In the case of *Clowd and Cloun (Blue)*, referentiality may be an "intimate geography" (in the sense of what the film director Lev Kulechov called "creative geography" in cinema). In Horn's work, clouds and rivers establish liquid time. "When you photograph water you strip it of its form: of its restless, liquid reality," she adds. The linearity of a river, or the distant yet intense familiarity of clowns and clouds, arrives as the perimeter of a dissociative experience.

When Horn states that "indivisible continuity is intrinsic to water," she announces another function of *Clowd and Cloun (Blue)*: the creation of variable but unified constructions out of multiple individual photographs. A reference to the theory of montage in cinema is necessary here[5]: Horn is symmetrically distant from the montage theories of Kulechov (disbelief in the single image), Sergei Eisenstein and Vsevolod Pudovkin (cut/montage, time/space) and André Bazin (the long take). Louise Neri has argued that "Horn's relational history of places recognizes that life, as it discloses itself spatially, is dynamic."[6] Horn has expanded Emily Dickinson's line "Best witchcraft is geometry" to organize that liquid geometry in each person's vision.

Horn incorporates in *Clowd and Cloun (Blue)* the phantasmatic flux of the Thames, or any river. The work puts the viewer inside a cinematic sphere. The constitution of time here differs from the rigid structure of time in the cinema: comparing the two, Horn says, "The acquiring of an actual experi-

ence is also the content of the work."[7] As causality is dispersed, the active gaze takes over the center of a new gravity of time.

3 : LE COMÉDIEN Horn's *cloun* is not Diderot's *comédien*. Identity here is not reducible to "closure"; the clown never sits still to "perform" his oxymoron, the "frozen movement." In fact Horn seems closer to the dissent from Diderot mounted by Jean-Louis Barrault, who defended the osmosis between actor and character in an effort of alternation and simultaneity.

Clowd and Cloun (Blue) is a sculptural manipulation of subjective plasticity. No matter how diaphanous the clown might look, disembodiment is never reached. A sculptor, Horn carves water and other fluidities: light (photography), emotional states, a clown, Iceland, language. She might say they are verbs. The clown reveals the libido's capacity to freely change the object and mood of satisfaction. He thus stands opposed to difficulty of change in viscosity. It is reasonable to conclude that the images of the clown stand for the plasticity of the libido in conflation with language.

The clown is the instinctual aim of the camera. Each one paradoxically asserts sameness across difference: the changing face of the clown will never be familiar, it leaves no room for assumptions, yet the clown is always immutably the same across innumerable states of identity, even while his "sensibility" stays far from the surface. As studies in physiognomy can be identified with the history of psychology, *Clowd and Cloun (Blue)* should be situated in a historical lineage with Leonardo, Géricault, and Bacon. Works of Horn's like *You Are the Weather* and *Clowd and Cloun (Blue)* define her art as "the idea of an encyclopedia of identity."[8] But Horn is an artist with a doubt: "Can the river dissolve your identity?"

4 : THE FORM RIVER In a strategic situation between codified vision and linguistic norms, Horn empowers the viewer. In *Clowd and Cloun (Blue)* the viewer is in a situation in which the mind contemplates not the flux of becoming but something discerned inside that flux as its law.[9] "Usually," says the artist, "the subject matter of the image is not the subject matter of the work"—in this case, then, neither cloud nor clown.[10] Horn shot her pictures

of cloud movements and clown movements—physics and duration—in real time, then refined their linguistic existence by interweaving the senses. Homophony, a sensorial twist, rearticulated them as *clowd* and *cloun*. In *Clowd and Cloun (Blue)* there is no mutability outside visual labor.

Unlike Diderot's detached *comédien*, the viewer of Horn's work is offered the opportunity "to make the sensible experience more present" and to "sense the nonvisible."[11] Horn works against semiological or grammatological reduction. The eye, through the *cloun*, writes desire—water is sexy, she further says, adding, "People have much more knowledge than they realize. I try to reach the viewer by addressing the bodily and not just the mental/nonphysical being."[12] Noam Chomsky considers it a first goal of generative grammar to answer the question, "What is the nature of the intuitive, unconscious knowledge, which (in particular) permits the speaker use his language?"[13] Thus the artistic model of Horn's works integrates the implicit intelligence of the viewer and makes it explicit as a strategic generative turn. Works like *Still Water* and *Clowd and Cloun (Blue)* help to define Horn's œuvre as a model of a generative visual grammar.

"When you say "water," are you talking about the weather or about yourself?" *Clowd and Cloun (Blue)* turns the viewer from a wanderer into an epistemological agent, a linguistic player, a visual laborer. "The viewer must take responsibility for being there, otherwise there is nothing there."[14] In general terms, Horn's art constructs a site where the generative gaze experiences unrest, a process of cognition, the practice of phenomenological perception, or the utterance of desire. If, for the artist, "the opacity of the world dissipates in water," it is part of the viewer's duty to dissipate that opacity.

INCONCLUSIONS AND FOOTNOTES Roni Horn is an artist of language, *écriture* (writing), and the book. Language excites the possibility of speaking to the foundational relation of art and the erratic in existence. Language—and here Horn's Jewish cultural heritage must be considered—excites the possibility of creating the Book. "Everything enters into, transpires in the book. This is why the book is never finite," says Derrida in *Writing and Difference*.[15] Writing is said to be the anguish of the Hebraic *Ruah*,

the Spirit that moved on the face of the waters. Horn develops the strategic disposition to which Derrida refers, which acts inside the field and its powers, turns against it and its devices in order to produce a force of dislocation—the *clowd* or the *cloun*—that spreads through the whole system, establishing fissures in it in all directions and delimiting it from all sides.

Horn has asked me, "Do you think [Clarice] Lispector invented the form river?"[16] Both of them stemming from the Jewish tradition, the writer and the artist set us in the flow of language, be it literary or visual, as the artistry of the precariousness of existence—or else of the nomadic, like water or consciousness. The translating of Lispector's work into English is meaningful: the title of one of her books, *Água viva*, which literally means "living water" and is a Portuguese term for "Medusa," becomes, in the delicate translation by Elizabeth Lowe and Earl Fitz, *The Stream of Life*.[17] Derrida reminds us that "the Jew's identification with himself does not exist."

The river is geometry[18] and geometry is witchcraft. Derrida argues that geometry is a theater—which would make it the place for the cloun, and symmetrically for the clowd, in *Clowd and Cloun (Blue)*. In fact water is a lens for seeing the human, and art is a refraction. Horn stands at the third margin of the river,[19] in other words at an absence of locality, a circumstance that does not exist except within—the place of the artist. What Roni Horn sees in water—ponds, rivers, clouds—is what one sees in her work: "delicate textures, fugitive structures: more elusive treasures!" And a severe generosity.

1 "It seems to me, retrospectively, that my entire identity formed around this, around not being this or that; a man or a woman." Roni Horn, in an interview with Claudia Spinelli, Basel, June 1995. In the artist's archives.

2 Jean-François Lyotard, *Discours, figures*, Paris, 1971, p. 217.

3 See Glen Mazis, "Merleau-Ponty, Derrida and Joyce's *Ulysses*: Is Derrida Really Bloom and Merleau-Ponty Dedalus, and Who Can Say 'Yes' to Molly?," in M. C. Dillon, ed., *Merleau-Ponty and Derrida on Seeing and Writing*, Atlantic Highlands, N.J., 1997, p. 167.

4 Horn, *Another Water*, Zurich, 2000. All quotations of Horn without indication of source or author come from this artist's book.

5 See Paulo Herkenhoff, "The Melody of Desire: The Art of Alair Gomes," in Christian Caujolle, Herkenhoff, Joaquim Paiva, et al., *Alair Gomes*, Paris, 2001, pp. 132–33.

6 Louise Neri, "Roni Horn: To Fold," in Neri, Lynne Cooke, and Thierry de Duve, *Roni Horn*, London, 2000, p. 60.

7 Horn, interview with Cooke, in ibid., p. 23.

8 Horn, in the interview with Spinelli.

9 I am indebted to Gordon Teskey in this paragraph.

10 Horn, in the interview with Cooke, p. 18.

11 Horn, in the interview with Spinelli.

12 Ibid.

13 Noam Chomsky, *On Language*, New York, 1998, p. 109. This paragraph benefits from Mitsou Ronat's introduction to the chapter "The Birth of Generative Grammar" in this book.

14 Horn, in the interview with Spinelli.

15 Jacques Derrida, *Writing and Difference*, trans. Alan Bass, Chicago, 1978, p. 75.

16 In an e-mail to the author, November 22, 2001. Horn is referring to the Brazilian Jewish writer Clarice Lispector, from whose book *The Apple in the Dark* (1967) she chose a fragment for Neri, Cooke, and de Duve, *Roni Horn*. Together with João Cabral de Melo Neto and João Guimarães Rosa, Lispector is a leading figure of the so-called «Generation of 45» in Brazilian literature.

17 Lispector, *The Stream of Life*, trans. Elizabeth Lowe and Earl Fitz, Minneapolis, 1989.

18 The reference here is to Melo, who dealt with the rivers of Recife as the scene of the social drama. His poetry is marked by a plasticity that includes geometry, color, space, and drought. Melo was a friend of Joan Miró's and of Antoni Tàpies's, and is a reference for Brazil's *Poesia Concreta*.

19 *A terceira margem do rio*, "the third margin of the river," is the title of a short story by Rosa. His literature involves a delicate blend of vernacular, erudite, experimental, and inventive language.

20 This passage should be considered in reference to Edmond Jabbès's *Le Livre des questions*, Paris, 1963, as discussed and quoted in Derrida, *Writing and Difference*, p. 69.

PAULO HERKENHOFF
KÜNSTLERISCHER DIREKTOR DER XXIV BIENNALE
SÃO PAULO (1998), LEBT IN RIO DE JANEIRO

Roni Horns unerfaßbarer Schatz

In seinem *Paradoxe sur le comédien* (1781) behauptete Diderot, daß ein Schauspieler Unempfindlichkeit und gefühlsmäßige Distanz brauche, um eine Rolle zu spielen. Diderots Titel verweist auf die semantischen Fragestellungen im visuellen System, das Roni Horn in *Clowd and Cloun (Blue)* verwendet: Paradox, (Un-)Empfindlichkeit und der Komödiant (das performative Element, sei's Wasser oder ein Clown). Die Arbeit ist eine Installation, in der sich sechzehn Fotografien eines Clowns und sechzehn Fotografien einer Wolke an den vier Wänden eines Raumes abwechseln. Jedes Bild des Clowns hält die übertriebenen Bewegungen der Figur fest; nur die Gesamtheit der Wolkenbilder verweist auf die Bewegung der Wolke. Der Strom dieser zwei Gruppen von dazwischen geschobenen Fotografien entwickelt sich um den Raum. Es gibt keinen vorgeschriebenen Weg, und Horn verwirft statische und symmetrische Binarismen mit jedem verfügbaren Mittel, von Geschlecht zu Topologie.[1] Man findet keine ausdrückliche Idee, welche die Gegenüberstellung der Fotografien einer Wolke und eines Clowns erklären würde, abgesehen von den Paradoxen, Oxymora, Aporien und Zauberkünsten in Horns poetischen Verfahren.

Die Fotografien in *Clowd and Cloun (Blue)* lassen die Figur des Clowns zu etwas Undeutlichem werden, und die flüchtige Stofflichkeit der Wolke wird zu einer kompakten Masse. Der Clown ist Wechsel. Er ist eine Form, etwas, das emotionalen Inhalts entbehrt, sei es Lachen oder Wehmut. Schauspielert er *à la Diderot?* Jedes Bild von ihm unterscheidet sich vom vorhergehenden, ein unzusammenhängendes Zeitfragment, das seine Autonomie durch die Formulierung seiner vorübergehenden Physiognomien oder Gesichtsausdrücke erhält. Währenddessen zieht die langsame, ephemere Wolke durch eine Gruppe von Bildern als durchgehende Folge und auf einer zirkulären Bahn. Horn ist keine Deterministin, und *Clowd and Cloun (Blue)* bringt eine Wechselhaftigkeit ohne Ursache in Gang. Wiederkehr und Kreislauf fassen die Bilder zusammen, stellen sie einander gleich. Die hermeneutische Herausforderung von *Clowd and Cloun (Blue)* artikuliert sich durch ein visuelles Quartett: die Wolke und der Clown, die Künstlerin und der Zuschauer.

1: FLÜSSIGKEIT

Horns Werk steht in Widerspruch zu Jean-François Lyotards Annahmen über die Akte des Lesens und Sehens: *«Recuser la visibilité du lisible»*, die Infragestellung der Sichtbarkeit des Lesbaren, und: *«Lire est entendre et non pas voir»*, Lesen ist Hören, nicht Sehen.[2] In der Konfrontation von Bild und Schrift (*écriture*), welche die Sichtbarkeit des Lesbaren gewährleistet, wird die Sprache zu einem Spannungspunkt. *Clowd and Cloun (Blue)* behält den linguistischen Rhythmus von *Still Water (The River Thames, for Example)* (1999) bei und verweist auf die implizite Textualität und Buchform von Horns *Dictionary of Water* (2001), einem reinen, wortlosen Fluß von rechteckigen Bildern von Wasser. Horn entfaltet die Gestalten des Wassers: «Wasser ist immer eine intime Erfahrung», schließt sie, «sogar als Regen oder Ozean oder Fluß». Wolken – Wasser in zerstäubtem Zustand –, fügen sich ein in Horns Diskurs über die flüssige Wirklichkeit: «Wenn ich Wasser betrachte, befällt mich ein Schwindelanfall der Bedeutung.»

Die paradoxe Topologie von *Still Water (The River Thames, for Example)* vermißt das Wasser an der Wurzel des Zugangs zur Sprache. Bilder von Wasser erhalten kleine Nummern, die zu hermeneutischen Fußnoten am Rand

korrespondieren, wie in der argumentierenden Methode des Philosophen Ludwig Wittgenstein. Horns Paradox in *Still Water* besteht im Vermessen des Unvermeßbaren, in *Clowd and Cloun (Blue)* besteht es aus dem Festhalten der Verwandlungen einer Wolke, von etwas, das sich in ständiger Verwandlung befindet. Sie beschäftigt sich (via Jacques Derrida) mit Baudelaires Unterfangen, das Unmögliche möglich zu machen. Horn hängt der Theorie an, daß die Unmöglichkeit der Sprache auch die Geburt der Sprache ist.[3] Die linguistische Textur ihrer Arbeit ist so dicht wie die Oberfläche irgendeines «fotografischen» Wassers. «Wasser murmelt»[4]: Wäre dies ein bloßer physischer Klang oder eine sprachliche Aussage?

2: KANN WASSER FESTGEHALTEN WERDEN? «Wie oft über Fotografie gesagt wird, diese Fotografie ist ein gefrorener Moment.» Horn entdeckt hier ein Oxymoron, «da ein gefrorener Moment überhaupt kein Moment ist». Wasser interessiert sie als linguistischer Körper, der nicht festgehalten werden kann. Horns fotografischer Blick umfaßt das Aufnehmen, Auswählen und Artikulieren von Bildern als semiologische Strategie. Er isoliert und dekontextualisiert sie als Weg, das Bedeuten zu problematisieren. Im Fall von *Clowd and Cloun (Blue)* ist die Referentialität vielleicht eine «intime Geographie» (im Sinne dessen, was Regisseur Lew Kuleschow im Film als «kreative Geographie» bezeichnete). In Horns Werk führen Wolken und Flüsse flüssige Zeit ein. «Wenn wir Wasser fotografieren, ziehen wir seine Form ab: ruhelose, flüssige Wirklichkeit», fügt sie hinzu. Die Linearität eines Flusses oder die entfernte, doch intensive Vertrautheit von Clowns und Wolken wird zum Umkreis einer dissoziativen Erfahrung.

Wenn Horn sagt, daß «untrennbare Kontinuität dem Wasser eigen ist», weist sie auf eine andere Funktion von *Clowd and Cloun (Blue)* hin: die Gestaltung von variablen, aber geeinten Konstruktionen aus verschiedenen einzelnen Fotografien. Hier wird ein Bezug zur Theorie der Montage im Kino notwendig.[5] Horn befindet sich in symmetrischer Distanz zu den Montagetheorien von Kuleschow (Unglauben in das Einzelbild), Sergej Eisenstein und Wsewolod Pudowkin (Schnitt/Montage, Zeit/Raum) und André Bazin (die lange Aufnahme). Louise Neri hat festgestellt: «Horns bezugsorientierte Ge-

schichte der Orte erkennt, daß Leben, wenn es sich räumlich entfaltet, dynamisch ist.»[6] Horn erweitert Emily Dickinsons Zeile: «Die beste Zauberkunst ist Geometrie», um die flüssige Geometrie im Blick jedes Menschen zu organisieren.

Horn baut das phantasmatische Fließen der Themse oder jedes Flusses in *Clowd and Cloun (Blue)* ein. Das Werk stellt den Besucher mitten in eine cinematische Sphäre. Die Beschaffenheit deren Zeit unterscheidet sich von der strengen Zeitstruktur des Films. Horn sagt über den Vergleich der beiden: «Das Erlangen einer tatsächlichen Erfahrung ist auch ein Inhalt des Werkes.»[7] Da die Kausalität zerstäubt ist, übernimmt der aktive Blick das Zentrum einer neuen Schwerkraft der Zeit.

3: LE COMÉDIEN

Horns *Cloun* ist nicht Didérots *comédien.* Identität läßt sich hier nicht auf «Geschlossenheit» reduzieren; der Clown sitzt nie still, um sein Oxymoron vorzuführen, den «gefrorenen Moment». In der Tat scheint er dem Widerspruch zu Diderot näher, den Jean-Louis Barrault formulierte, der die Osmose von Schauspieler und Charakter im Bemühen um Wechsel und Gleichzeitigkeit verteidigte.

Clowd and Cloun (Blue) ist eine skulpturale Manipulation subjektiver Plastizität. Wie durchscheinend auch immer der Clown aussehen mag, er erreicht nie Körperlosigkeit. Horn, eine Bildhauerin, meißelt Wasser und andere Flüssigkeiten: Licht (Fotografie), Gefühlszustände, einen Clown, Island, Sprache. Sie würde vielleicht sagen, es seien Verben. Der Clown zeigt das Vermögen der Libido, frei das Objekt und die Stimmung der Befriedigung zu wechseln. Er steht also im Gegensatz zur Schwierigkeit einer Änderung in zähflüssigem Zustand. Es ist vernünftig zu schließen, daß die Bilder des Clowns für die Plastizität der Libido in Verschmelzung mit der Sprache stehen.

Der Clown ist das instinktive Ziel der Kamera. Jeder einzelne von ihnen bestätigt paradoxerweise die Gleichheit in der Differenz: Das wechselnde Gesicht des Clowns wird nie vertraut sein, es lässt keinen Raum für Annahmen, doch der Clown ist unverändert derselbe in unzähligen Zuständen der Identität, sogar wenn seine «Sensibilität» fern der Oberfläche bleibt. Da physiognomische Studien mit der Geschichte der Psychologie gleichgesetzt werden

können, sollte *Clowd and Cloun (Blue)* in einen historischen Zusammenhang mit Leonardo, Bacon und Géricault gesetzt werden. Werke Horns, wie *You Are the Weather* und *Clowd and Cloun (Blue)*, definieren ihre Kunst als «die Idee einer Enzyklopädie der Identität».[8] Aber Horn ist eine Künstlerin mit einem Zweifel: «Kann der Fluß deine Identität auflösen?»

4: DER FORMFLUß In einer strategischen Situation zwischen kodifiziertem Sehen und linguistischen Normen stärkt Horn den Betrachter. In *Clowd and Cloun (Blue)* ist der Betrachter in einer Situation, in welcher der Geist nicht den Fluß des Werdens betrachtet, sondern etwas, das innerhalb dieses Flusses als dessen Gesetz wahrgenommen wird.[9] «Normalerweise», sagt die Künstlerin, «ist der Inhalt eines Bildes nicht der Inhalt des Werks.» In diesem Fall wäre es also weder Wolke noch Clown.[10] Horn schoß ihre Bilder von Wolkenbewegungen und den Bewegungen des Clowns – Physik und Dauer –, in der realen Zeit und verfeinerte dann deren linguistische Existenz durch ein Verweben der Sinne. Gleichklang, eine Tücke der Wahrnehmung, reartikuliert sie als *clowd* und *cloun*. In *Clowd and Cloun (Blue)* gibt es keine Wechselhaftigkeit außerhalb der visuellen Arbeit.

Anders als Diderots teilnahmslosem *comédien* bietet sich dem Betrachter von Horns Werk die Gelegenheit, «die sinnliche Erfahrung gegenwärtiger zu machen» und «das Unsichtbare zu spüren».[11] Horn arbeitet gegen die semiologische oder grammatologische Reduktion. Das Auge schreibt, durch den *cloun*, das Begehren – «Wasser ist sexy», sagt sie zudem und fügt hinzu: «Menschen verfügen über mehr Wissen, als ihnen bewusst ist. Ich versuche, den Betrachter zu erreichen, indem ich das Körperliche anspreche und nicht bloß das mentale/nicht-physische Wesen.»[12] Noam Chomsky betrachtete es als das erste Ziel der generativen Grammatik, folgende Frage zu beantworten: «Was ist das Wesen des intuitiven, unbewußten Wissens, das (im speziellen) dem Sprecher erlaubt, seine Sprache zu benutzen?»[13] Entsprechend bezieht das künstlerische Modell von Horns Werk die implizite Intelligenz des Betrachters mit ein und macht dies offensichtlich als eine strategische generative Wendung. Werke wie *Still Water* und *Clowd and Cloun (Blue)* helfen, Horns Werk als ein Modell für eine generative visuelle Grammatik zu definieren.

«Wenn du ‹Wasser› sagst, sprichst du dann über das Wetter oder dich selbst?» *Clowd and Cloun (Blue)* verwandelt den Betrachter von einem Wanderer in einen epistemologischen Agenten, einen linguistischen Spieler, einen Bildarbeiter. «Der Betrachter muß Verantwortung übernehmen, dort zu sein, andernfalls ist nichts dort.»[14] Allgemein gesprochen konstruiert Horns Kunst einen Ort, an dem der generative Blick Unruhe erfährt, einen Erkenntnisprozess, die Ausübung einer phänomenologischen Wahrnehmung oder den Ausdruck des Begehrens. Wenn für die Künstlerin «die Undurchsichtigkeit der Welt sich im Wasser auflöst», ist es Teil der Pflicht des Betrachters, diese Undurchsichtigkeit aufzulösen.

Unschlußfolgerungen und Fußnoten

Roni Horn ist eine Künstlerin der Sprache, der *écriture* (Schrift) und des Buches. Sprache erregt die Möglichkeit des Sprechens zu den grundlegenden Beziehungen der Kunst und des Erratischen in der Existenz. Sprache – und hier muß Horns jüdisches Kulturerbe in Betracht gezogen werden –, erregt die Möglichkeit, DAS Buch zu gestalten. «Alles findet seinen Weg ins Buch, verdunstet im Buch. Deshalb ist das Buch nie zu Ende», schreibt Derrida in *Schrift und Differenz*.[15] Schreiben sei die Angst des hebräischen *Ruah*, des Geistes, der über den Wassern schwebte. Horn entwickelt jene strategische Disposition, auf die Derrida verweist, die innerhalb des Feldes und seiner Kräfte wirkt, sich gegen dieses und dessen Mittel wendet, um eine Kraft der Neuverortung zu produzieren – die *Clowd* oder der *Cloun* –, die sich durch das ganze System verbreitet, Brüche in alle Richtungen bewirkt und es von allen Seiten entgrenzt.

Horn fragte mich: «Glaubst du, dass Clarice Lispector die Form Fluß erfunden hat?»[16] Aus derselben jüdischen Tradition stammend setzen uns die Schriftstellerin und die Künstlerin in den Fluß der Sprache, sei sie literarisch oder visuell, als einer Kunst des Prekären der Existenz – oder des Nomadischen, wie das Wasser oder das Bewusstsein. Die Übersetzung von Lispectors Werk auf Englisch ist bedeutsam: *Água Via*, der Titel eines ihrer Bücher, heißt wörtlich «lebendes Wasser» und ist ein portugiesischer Name für «Medusa». In der feinsinnigen Übersetzung von Elizabeth Lowe und Earl Fitz

wird dies zu *The Stream of Life* (Der Strom des Lebens).[17] Derrida erinnert uns daran, daß «es keine Identifikation des Juden mit sich selbst gibt».

Der Fluß ist eine Geometrie, und Geometrie ist Zauberkunst. Derrida meint, daß Geometrie ein Theater sei – was sie zum Ort für den *cloun* und, symmetrisch dazu, die *clowd* in *Clowd and Cloun (Blue)* machen würde. Tatsächlich ist Wasser eine Linse, um den Menschen zu sehen, und Kunst ist eine Brechung.[18] Horn steht am dritten Rand des Flusses,[19] in anderen Worten in der Abwesenheit eines Ortes, ein Umstand, der nicht existiert, außer am Platz des Künstlers.[20] Was Roni Horn in Wasser sieht – Teiche, Flüsse, Wolken – ist, was wir in ihrem Werk sehen: »Delikate Texturen, fliehende Strukturen: mehr unerfaßbare Schätze!» Und eine strenge Großzügigkeit.

1 «Rückblickend scheint mir, dass meine ganze Identität sich um dies geformt hat, weder das eine noch das andere zu sein; ein Mann oder eine Frau.» Roni Horn, in einem Interview mit Claudia Spinelli, Basel, Juni 1995. Archiv der Künstlerin.

2 Jean-François Lyotard, *Discours, figures*, Paris, 1971, S. 217.

3 Siehe Glen Mazis, «Merleau-Ponty, Derrida and Joyce's *Ulysses*: Is Derrida Really Bloom and Merleau-Ponty Dedalus, and Who Can Say 'Yes' to Molly?,» in M. C. Dillon, ed., *Merleau-Ponty and Derrida on Seeing and Writing*, Atlantic Highlands, N.J, 1997, S. 167.

4 Horn, *Another Water*, Zurich, 2000. Alle Zitate von Horn sind aus diesem Buch, soweit nicht anders vermerkt.

5 Siehe Paulo Herkenhoff, «The Melody of Desire: The Art of *Alair Gomes*,» in Christian Caujolle, Herkenhoff, Joaquim Paiva, et al., Alair Gomes, Paris, 2001, S. 132–33.

6 Louise Neri, «Roni Horn: To Fold,» in Neri, Lynne Cooke, and Thierry de Duve, *Roni Horn*, London, 2000, S. 60.

7 Horn, Interview mit Cooke, S. 23.

8 Horn, Interview mit Spinelli.

9 Ich bin Gordon Tesky zu Dank verpflichtet in diesem Abschnitt.

10 Horn, Interview mit Cooke, S. 18.

11 Horn, Interview mit Spinelli.

12 Ibid.

13 Noam Chomsky, *On Language* (New York, 1998), S. 109. Dieser Abschnitt wurde angeregt durch Mitsou Ronats Einleitung zu «The Birth of Generative Grammar» in diesem Buch.

14 Horn, Interview mit Spinelli.

15 Jacques Derrida, *Writing and Difference*, Chicago, 1978, S. 75.

16 In einer E-mail an den Autoren, 22. November, 2001. Horn bezieht sich auf die jüdisch-brasilianische Clarice Lispector, aus deren Buch *The Apple in the Dark* (1967) sie ein Fragment für: Neri, Cooke, and de Duve, *Roni Horn* auswählte. Zusammmen mit João Cabral de Melo Neto und João Guimarães Rosa ist Lispector eine führende Figur der sogenannten «Generation von 45» in der brasilianischen Literatur.

17 Lispector, *The Stream of Life*, übersetzt von Elizabeth Lowe und Earl Fitz, Minneapolis, 1989.

18 Hier wird auf Melo verwiesen, der die Flüsse von Recife als ein Ort sozialer Dramen behandelte. Seine Dichtung zeichnet sich durch eine Plastizität aus, die Geometrie, Farbe, Raum und Dürre umfaßt. Melo war ein Freund von Juan Miró und Antoni Tàpies und ist ein brasilianischer Vertreter der brasilianischen *Poesia Concreta.*

19 *A terceira margem do rio* (Der dritte Rand des Flusses) ist der Titel einer Kurzgeschichte von Rosa. Seine Literatur ist eine delikate Mischung aus Umgangssprache, gehobener, experimenteller und erfinderischer Sprache.

20 Diese Passage sollte im Zusammenhang mit Edmond Jabès *Le Livre des questions*, Paris, 1963 – besprochen und zitiert in: Derrida, *Writing and Difference*, S. 69 – gelesen werden.

Her, Her, Her, and Her

Her, Her, Her, and Her, 2001–2003, was photographed in a locker room in Reykjavík. Sixty-four one foot square black-and-white photographs printed on paper are assembled, quilt-like, into an 8 x 8' unit. This unit is paired with a complementary assembly of sixty-four images shifted in both time and space. The two units are hung opposite to each other.

Her, Her, Her, and Her, 2001–2003, wurde aufgenommen in einer Umkleidekabine in Reykjavík. 64 quadratische schwarzweiße Fotografien, je 0,3 x 0,3 m, gedruckt auf Papier, sind quilt-ähnlich angeordnet in einem Feld von 2,4 x 2,4 m. Dieses Feld ist gepaart mit einer komplementären Zusammenstellung von 64 Bildern, verschoben in Zeit und Raum. Die beiden Felder hängen einander gegenüber.

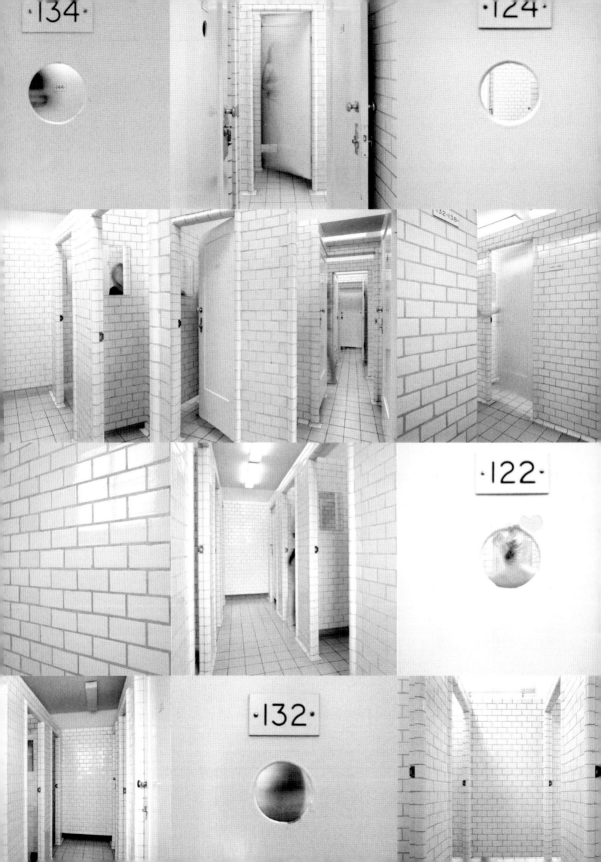

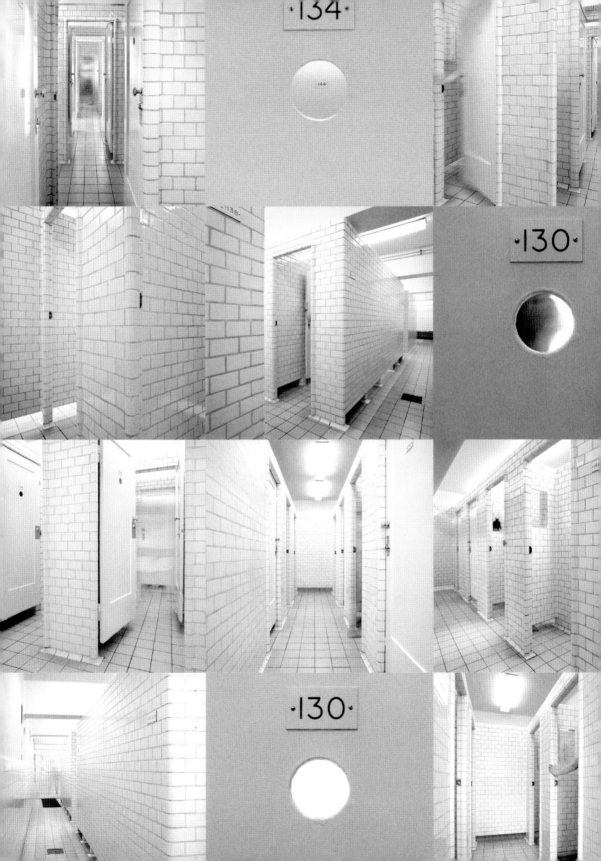

B A R B A R A K R U G E R
I S A N A R T I S T L I V I N G I N
N E W Y O R K A N D L O S A N G E L E S

Again, Again, Again, and Again

Tiles. Tiles like bricks. Tiles that are bricks with a difference. Tiles stacked or placed side by side. Tiles that are white and glazed like cakes ripe with icing. Tiles that start like a puzzle and end like a maze. Tiles that are cold to the touch or damply warm. Tiles that wrap around corners like a zany embrace. Tiles that support leaning backs and steady feet. Tiles that read horizontally and gather to form paths that go somewhere and nowhere, from a way in to no way out. Tiles that are square and underfoot and lead from wall to wall. Walls that divide and conquer. Walls that keep us at a distance. Walls that steer the eye. Walls that offer breathing room. Rooms to change from public to private and back. Rooms where the figure becomes the body. Rooms that magnify the body and shrink the world. Rooms for both hiding and seeking. Rooms that take you away from it all. Rooms that close doors. Doors that multiply in rows like chorus lines. Doors adorned with heavy

118

metal, donning knobs and locks like a bejeweled starlet on Oscar night. Doors with their bottoms up, exposing a slight sight of feet first. Numbered doors that suggest sequence, order, and identity. Open doors that present both welcome and vacancy. Closed doors that leave you alone. Closed doors with openings that show and tell. Openings that frame and crop, that give and take away. Openings to shoulders, backs, and the nape of the neck. Openings that look in and out. Out to the world and in to the body. Bodies being put in their place. Bodies both attentive and exhausted. Bodies doubled in foggy mirrors. Bodies seen stealthily like glancing blurs. Bodies known and unknown, both contained and gone in a flash. Bodies painfully self-conscious and brazenly showy. Bodies that know boundaries and bodies that are all over the place. Bodies looking or turning away. Bodies both camera shy and camera ready. Bodies fat and thin, rugged or thin-skinned. Skin that is old or new. Skin that is pink or beige or tan or black. Skin that is hot as hell or cool as a cucumber. Skin that is ignored or pampered, functional or formalized, flesh but not meat. Skin that saves hair only on the head and skin that sprouts. Hair running wild or militantly tamed. Hair that is squeaky clean or reeking with potions, blow-dried or straight as a stick. Hair pulled back tightly or lazily draping the eye. Eyes that are unfettered with decor or fringed with bangs. Eyes open or closed or somewhere in between. Eyes that are blue, green, or brown, wet or dry. Eyes that return the gaze or look away. Gazes that are incidental or instrumental, strategic or innocent. Gazes that are naked eyes or loaded with lenses. Gazes as caresses and weapons, observations and anthropology. Gazing as science, sex, and architecture. Gazing as language for the deaf. Gazing as seeing but not believing. Gazing as the art of looking. Gazing as the seeing eye.

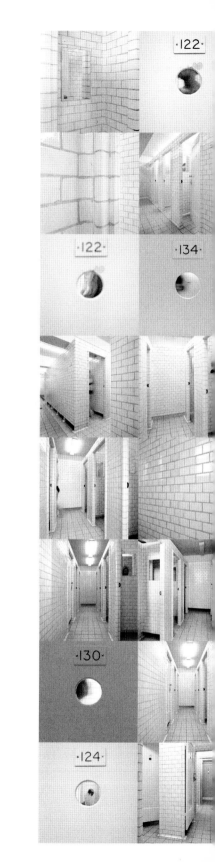

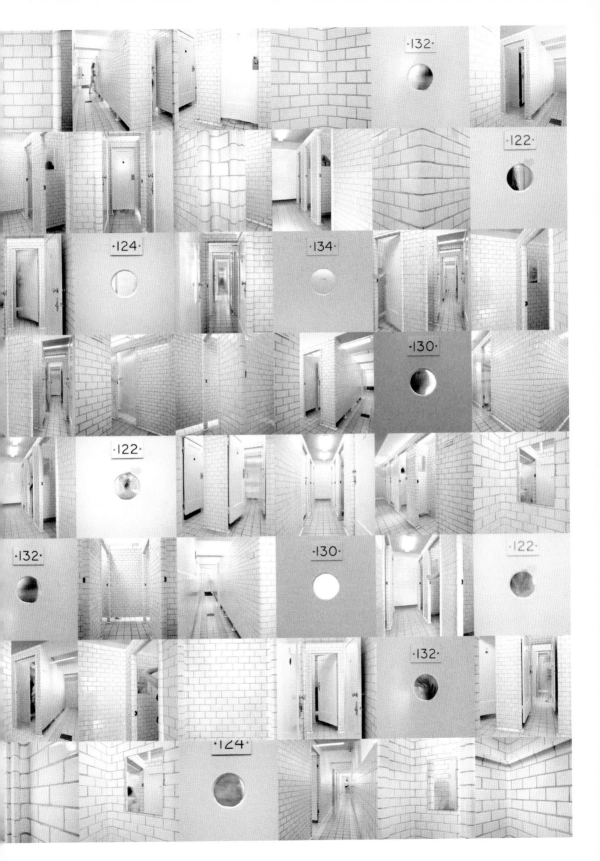

BARBARA KRUGER
IST KÜNSTLERIN UND LEBT IN
NEW YORK UND LOS ANGELES

Wieder, wieder, wieder und wieder

Fliesen. Fliesen wie Ziegelsteine. Fliesen die Ziegelsteine mit einem Unterschied sind. Fliesen, aufgestapelt oder Seite an Seite gelegt. Fliesen, die weiß sind und glasiert wie Kuchen mit Zuckerguß. Fliesen, die wie ein Puzzle beginnen und wie ein Irrgarten enden. Fliesen, die sich bei einer Berührung kalt anfühlen oder feuchtwarm. Fliesen, die sich um Ecken schmiegen wie eine skurrile Umarmung. Fliesen, die angelehnte Rücken und standfeste Füße stützen und von Wand zu Wand führen. Fliesen, die sich horizontal lesen und Pfade formen, die irgendwohin und nirgendwohin führen, von einem Weg hinein zu keinem Ausweg. Fliesen, die viereckig und unter Füssen sind und von Wand zu Wand führen. Wände, die teilen und erobern. Wände, die uns in einer Entfernung halten. Wände, die das Auge steuern. Wände, die Atemraum bieten. Räume, um vom Öffentlichen ins Private zu wechseln und zurück. Räume, wo die Zahl zum Körper wird. Räume, die den Körper vergrößern und die Welt schrumpfen lassen. Räume, zum Verstecken wie zum Suchen. Räume, die dich aus allem rausreißen. Räume, die Türen schließen. Türen, die sich in Reihen, wie ein Chor, vervielfältigen.

Türen, geschmückt mit schwerem Metall, herausgeputzt mit Türknäufen und Schlössern wie ein juwelengeschmücktes Starlet an einer Oscarnacht. Türen mit Ritzen, die zuerst einen flüchtigen Blick auf die Füße freigeben. Numerierte Türen, die Folge, Ordnung und Identität ahnen lassen. Offene Türen, die Willkommen und Leere anbieten. Geschlossene Türen, die dich alleine lassen. Geschlossene Türen mit Ritzen, die zeigen und erzählen. Türritzen, die einrahmen und anschneiden, die geben und wegnehmen. Türritzen auf Schultern, Rücken und Genick. Türritzen, die nach innen und nach außen blicken. In die Welt hinaus und in den Körper hinein. Körper, die an ihren Platz gestellt werden. Körper, sowohl aufmerksam wie erschöpft. Körper, verdoppelt in nebligen Spiegeln. Körper, verstohlen erspäht wie verschwommene flüchtige Blicke. Körper, bekannt und unbekannt, gleichzeitig enthalten und vergangen in einem Blitz. Körper, schmerzhaft befangen und unverschämt zeigefreudig. Körper, die Grenzen kennen, Körper, die sich nach allen Seiten breit machen. Körper, die hinsehen oder sich abwenden. Körper, kamerascheu und bereit für die Kamera. Körper, fett und dünn, abgehärtet und dünnhäutig. Haut, die alt oder jung ist. Haut, die rosa oder beige oder gebräunt oder schwarz ist. Haut, die heiß wie die Hölle oder kühl wie eine Gurke ist. Haut, die vernachlässigt oder gehätschelt wird, funktional oder geformt, Fleisch, aber kein Schlachtfleisch. Haut, die Haare nur auf dem Kopf bewahrt, und Haut, die sprießt. Haare, wild wuchernd oder streng gezähmt. Haar, quietschsauber oder triefend, gefönt oder steckengerade. Haare, straff zurückgenommen oder nachlässig die Augen verdeckend. Augen, frei von Schmuck oder lockengefranst. Augen, offen oder geschlossen oder irgendwo dazwischen. Augen, die blau, grün oder braun sind, feucht oder trocken. Augen, die den Blick erwidern oder wegschauen. Blicke, die zufällig sind oder zweckbestimmt, strategisch oder unschuldig. Blicke, die nackte Augen sind oder mit Linsen bewaffnet. Blicke als Liebkosungen oder Waffen, Beobachtungen und Anthropologie. Sehen als Wissenschaft, Sex und Architektur. Sehen als Sprache der Tauben. Sehen als Sehen, aber nicht Glauben. Sehen als die Kunst des Hinschauens. Sehen als das sehende Auge.

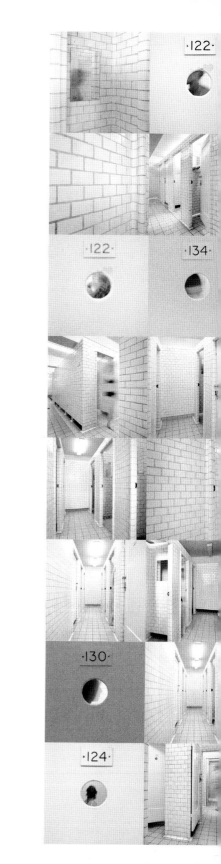

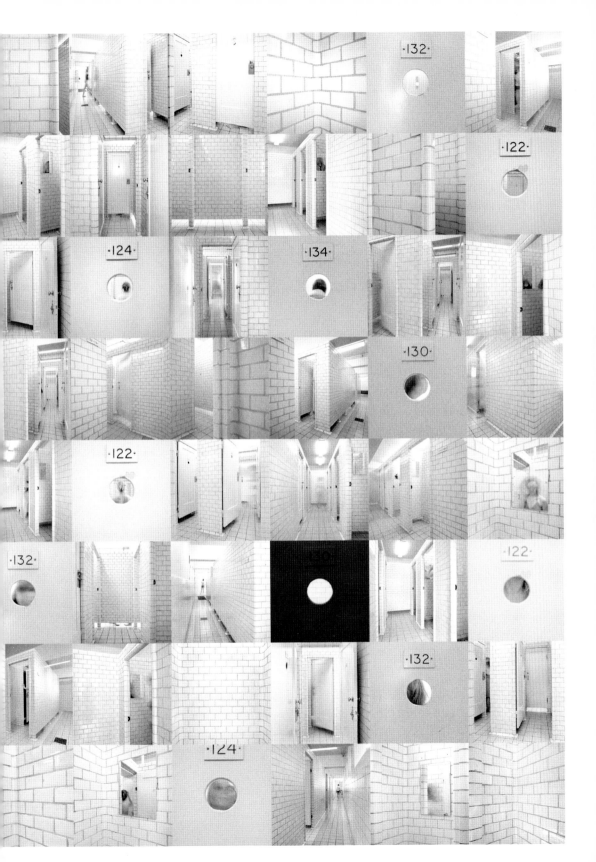

GENERAL ACKNOWLEDGEMENTS

We would like to thank David Frankel for the careful editing, Martin Jaeggi and Dirk Eckart for the precise translations; Therese Seeholzer and Urs Stahel for the editing in German; Therese Seeholzer also for the smooth organization. We would like to thank Pietro Mattioli and his team for the precise installation of the exhibition, Joy Neri for ensuring the financial foundation of the show, and Marion Bernhard for the friendly administration. Hanna Koller has as always carefully designed this book. A particularly heartfelt thank you goes to Roni Horn for her engagement with this project and the spirited conversations on art and politics.

We would like to thank the lenders to the exhibition for their generous support:

Galerie Hauser & Wirth & Presenhuber, Zurich, Galérie Xavier Hufkens, Brussels, Jablonka Galerie, Cologne, and Matthew Marks Gallery, New York.

ARTIST'S ACKNOWLEDGEMENTS

Thanks to Georgia Loy Horn Weinberg for her contribution to *This is Me, This is You*. Gerry Vezzuso for his work on *This is Me, This is You*. To Gerhard Steidl for his support of the book-works over the years. To Michael Bongar for his generosity and commitment and for being the clown in *Cabinet of*, and *Clowd and Cloun (Blue)*. Greta Olafsdóttir for her assistance on the clown photo sessions. Darin Mickey and Thilde Jensen for printing the original editions of clowns. To Kathleen Merrill-Campano and the Lannan Foundation for their support on the Thames projects. To Pascal Dangin for his extraordinary support of my work. And to his Box Studios: Amy Bernhardt, Amelia Bauer, Molly Welch, Maria Einarsson, and John Eric Jacono, and the rest of the crew for their unique contribution to the production of the original editions of *Her, Her, Her, and Her*, as well as their generous support of *Cabinet of*, and *Her, Her, Her, and Her*, the books. Frida Björk Ingvarsdóttir for her help as editor and translator of my writings on the visual editorials for *Morgunbladid*, Reykjavík and *Another Water (The River Thames, for Example)*. For their contributions to this publication, special thanks to the writers: Thierry de Duve, Paulo Herkenhoff, bell hooks, Barbara Kruger, Elisabeth Lebovici, and Urs Stahel. And finally to Urs Stahel for the pleasure of working with him.

PHOTO CREDITS

Original photographs for *Another Water (The River Thames, for Example)*: Nic Tenwiggenhorn, Düsseldorf. Original photographs for *Cabinet of, Clowd and Cloun (Blue), This is Me, This is You, Her, Her, Her, and Her*, and *Pi*: Roni Horn. Installation views *This is Me, This is You*: Oren Slor, courtesy Matthew Marks Gallery, New York. Installation views *Clowd and Cloun (Blue)*: Nic Tenwiggenhorn, courtesy Matthew Marks Gallery, New York. Installation photographs of *Pi* at Patrick Painter Gallery, Los Angeles: Doug Parker, Los Angeles. Installation photograph of *Cabinet of*: Galérie Yvon Lambert, Paris.

DANK

Wir danken David Frankel für das umsichtige englische Lektorat, Martin Jaeggi und Dirk Eckart für die genauen Übersetzungen; Therese Seeholzer und Urs Stahel für das deutsche Lektorat; Therese Seeholzer zudem für die sorgfältige Organisation. Pietro Mattioli und seinem Team danken wir für die präzise Installation der Ausstellung, Joy Neri für ihre Sorge um das finanzielle Fundament und Marion Bernhard für die freundliche Administration. Hanna Koller besorgte wie immer sorgfältig die Gestaltung des Buches. Ein besonders herzlicher Dank gilt Roni Horn für ihr Engagement in diesem Projekt und die angeregten Gespräche über Kunst und Politik. Wir danken den Leihgebern Galerie Hauser&Wirth&Presenhuber, Zürich, Galérie Xavier Hufkens, Brüssel, Jablonka Galerie, Köln, und Matthew Marks Gallery, New York, für ihr grosszügiges Entgegenkommen.

DANK DER KÜNSTLERIN

Ein Dank an Georgia Loy Horn Weinberg für ihren Beitrag zu *This is Me, This is You*. An Gerry Vezzuso für seine Arbeit an *This is Me, This is You*. An Gerhard Steidl für seine Unterstützung meiner Bucharbeiten über die Jahre. An Michael Bongar für seine Großzügigkeit und Unterstützung und weil er den Clown *Cabinet of* und *Clowd and Cloun (Blue)* spielte. Greta Olafsdóttir für ihre Assistenz beim Aufnehmen der Clownfotografien. An Darin Mickey und Thilde Jensen für das Drucken der Originaleditionen der Clowns. An Kathleen Merrill-Campano und die Lannan Foundation für deren Unterstützung meiner Themse-Projekte. An Pascal Dangin für seine außergewöhnliche Unterstützung meiner Arbeit. Und an seine Box Studios: An Amy Bernhardt, Amelia Bauer, Molly Welch, Maria Einarsson, John Eric Jacono und den Rest der Mitarbeiter für ihren einmaligen Beitrag an die Herstellung der Originaleditionen von *Her, Her, Her, and Her* und die großzügige Unterstützung der Bücher von *Cabinet of* und *Her, Her, Her, and Her*. Frida Björk Ingvarsdóttir für ihre Hilfe als Lektorin und Übersetzerin meiner Texte für die visuellen Beiträge in *Morgunbladid*, Reykjavík, und *Another Water (The River Thames, for Example)*. Für ihre Beiträge in diesem Katalog geht ein spezieller Dank an die Autoren: Thierry de Duve, Paulo Herkenhoff, bell hooks, Barbara Kruger, Elisabeth Lebovici und Urs Stahel. Und schließlich an Urs Stahel für das Vergnügen, mit ihm zu arbeiten.

FOTONACHWEIS

Originalfotografien für *Another Water (The River Thames, for Example)*: Nic Tenwiggenhorn, Düsseldorf. Originalfotografien für *Cabinet of, Clowd and Cloun (Blue), This is Me, This is You, Her, Her, Her, and Her*, und *Pi*: Roni Horn. Installationsansichten *This is Me, This is You*: Oren Slor, courtesy Matthew Marks Gallery, New York. Installationsansichten *Clowd and Cloun (Blue)*: Nic Tenwiggenhorn, courtesy Matthew Marks Gallery, New York. Installationsfotografien von *Pi* in der Patrick Painter Gallery, Los Angeles: Doug Parker, Los Angeles. Installationsfotografie von *Cabinet of*: Galérie Yvon Lambert, Paris.

PUBLISHED BY

Fotomuseum Winterthur, Winterthur, and Steidl Verlag, Göttingen, on the occasion of the
exhibition "Roni Horn: If on a Winter's Night ... Roni Horn ..." at Fotomuseum Winterthur,
3/29–6/1 2003. Printed by Steidl, Göttingen.

© 2003 for this edition: Steidl Verlag, Göttingen, and Fotomuseum Winterthur
© 2003 for the texts: the authors
© 2003 for the photographs: the artist

HERAUSGEGEBEN VON

Fotomuseum Winterthur, Winterthur, und Steidl Verlag, Göttingen, aus Anlaß der Ausstellung
«Roni Horn: If on a Winter's Night ... Roni Horn ...» im Fotomuseum Winterthur, 29.3.–1.6.2003.
Druck: Steidl, Göttingen.

© 2003 für diese Ausgabe: Steidl Verlag, Göttingen, und Fotomuseum Winterthur
© 2003 für die Texte: die Autoren
© 2003 für die Fotografien: die Künstlerin

ISBN 3-88243-911-4
Printed in Germany

UBS AG
Main sponsor of the exhibition / Hauptsponsor der Ausstellung